Magic

Canon

CLASSIC CAMERAS

A-1
AT-1
AE-1
AE-1 Program
T50 T70 T90

Harold Francke / Bob Shell

Magic Lantern Guide to
Canon Classic Cameras

Fourth Printing 1999
Published in the United States of America by

Silver Pixel Press
A Tiffen Company
21 Jet View Drive
Rochester, NY 14624

From the German edition by Harold Francke
Translated by Bob Shell
Edited by Bob Shell

Printed in Germany by Kösel GmbH, Kempten

ISBN 1-883403-26-X

Contents

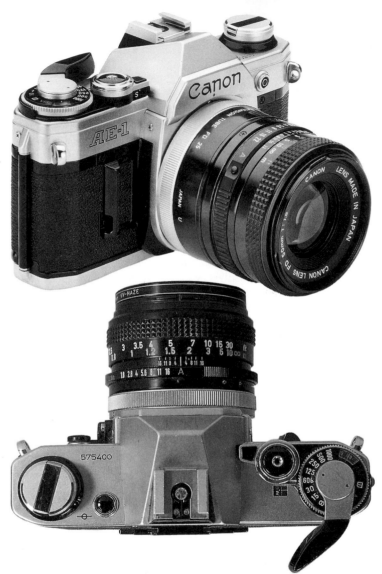

(Top) The Canon AE-1, Canon's first electronically controlled SLR camera, features a relatively compact body and modern styling. (Bottom) Controls on the top of the camera include (left to right) the film rewind assembly, battery check button, hot shoe with dedicated flash contacts, shutter release with self-timer lever, frame counter, and shutter speed dial surrounding the film advance lever.

Canon AE-1

The years 1975 and 1976 brought many new developments in Single Lens Reflex (SLR) camera technology. Minolta had successfully launched the new XE-1 camera. Through a rigorous development program, Pentax phased out the M42 screw mount and introduced the first K-series models, the KX, KM and K2, with a new bayonet mount. Nikon introduced the Nikkormat ELW (called Nikomat in some markets), an advanced camera that accepted a motor winder. Olympus was successfully selling the diminutive OM1 and had just introduced the automatic OM2. These two cameras put Olympus at the top of the growing SLR market for the first time.

Onto this competitive playing field Canon launched the AE-1, its first application of microprocessor technology in a consumer camera. With a smaller body, yet more advanced features, the AE-1 was controlled almost entirely by electronic rather than mechanical mechanisms and all of the electronics were driven by an internal mini computer. Available in both standard chrome and black body versions, the camera capitalized on the fact that electronics are smaller, lighter and more reliable than traditional mechanical controls. The mini computer of the AE-1 may not seem like much when compared to today's high-tech camera electronics but at the time of the AE-1's introduction it was really sensational. For the first time it offered very precise electronic control of shutter speeds. The camera could accept a winder for faster operation and when the camera was used with certain Canon electronic flash units the electronic flash synchronization speed was automatically set. All of this was done in a compact body with precision that never could have been matched by mechanical technology.

Basic Camera Operation

Installing the Battery

To access the battery compartment on the right front side of the AE-1, press in on the small latch on the bottom left of the battery compartment door. Then open this door, which hinges up and

toward the lens, and insert the 6-volt battery with the plus pole upward. The correct battery is the PX 28 silver oxide battery or an equivalent lithium or alkaline magnesium battery.

Battery Check: After installation check the battery's operation with the battery test button. You will find this on the left top side of the body next to the rewind knob. When the battery is properly installed and in proper operating condition, pressing the test button will cause the needle in the viewfinder to register at the test mark, which is in the same place as the f/5.6 aperture indicator. Check the battery often; if it fails, the shutter will not fire and other camera operations may not be correct. As a safeguard, it is advisable to change the battery at least once a year.

Loading the Film

Open the camera back by pulling up on the rewind knob. Take the end of the film and fit it into one of the slots in the take-up spool then insert the cassette into the left side of the camera, making sure that it fits properly onto the forked shaft of the rewind crank. Advance the film with the film advance lever until you are certain that it will not slip out of the take-up spool, then close the camera back. Once the camera back has been closed turn the rewind crank in the direction of the arrow until the slack has been taken up. Then, advance the film through two more blank exposures. Watch the rewind crank to make sure it turns, showing that film is actually moving through the camera. Since the counter will advance whether the film is properly loaded or not, this is the only guarantee that the film is actually advancing when it is wound.

Caution: While loading the film be careful not to touch the shutter. The shutter curtains are very delicate.

Film Transport

For convenience, an internal ratchet allows film to be advanced either with one long or with several short strokes of the film advance lever. The frame number is shown in the frame counter window on the top right side of the camera.

The film can also be advanced with the accessory Winder A or A2 for easier and faster operation. When the film winder is attached, the film advance lever should be stowed inward as far

as it goes. Film transport with the winder achieves a maximum speed of two pictures per second.

Rewinding the Film
When the film will not advance any further and the shutter will not fire, you are at the end of the roll. To rewind the film, press in on the film rewind release button on the bottom of the camera and use the small folding crank on the top of the film rewind knob to wind the film back into the cassette. Turn the crank in the direction indicated by the arrow engraved on it. You will know when the film is completely rewound because the slight resistance caused by the film being pulled through the mechanism will cease and the rewind crank will turn more freely. You can then remove the film cartridge by pulling up on the rewind knob and opening the camera back. This automatically resets the frame counter to the S (start) position.

The back of the AE-1 has a memo holder, which accepts the end panel from the box of film in use as a reminder.

Setting the Film Speed
The shutter speed dial on the right side of the camera also acts as a film speed selector dial. To set the film speed you must lift up

slightly on the outer knurled rim of this dial and rotate the dial. The film speeds are shown in the cut out section on the dial. You can set speeds from ISO 25 to ISO 3200.

The Viewfinder

The view through the eyepiece in the AE-1 appears on the camera's fine grain focusing screen. In the center of the screen is a focusing aid that combines a circle with a microprism or Dodin prism engraving, with a split-image rangefinder in the center. This allows for easy focusing on almost all types of subjects. To the right of the focusing screen and outside of the picture area is the aperture scale which shows aperture values from f/1.2 to f/22. Above the aperture scale is a red M that blinks when the camera is set to manual operation. A moving needle points to the aperture selected by the camera in Shutter Priority autoexposure mode. Underneath the scale is a red LED that will flash to warn of underexposure. It will also flash when the camera is set for "B" and an exposure is made. At the top of the aperture scale is a red bar that will move into position to block out unavailable apertures. For example, if a lens only goes to f/16, the bar will block out f/22. Also on the same scale you will see a small mark next to f/5.6. The metering needle must come to this mark during battery testing or the battery is no longer up to full level and should be replaced.

The Light Meter

The light meter is center-weighted, which means that the major emphasis of the exposure is given to the central part of the image. The upper part of the image is given less priority so that bright sky in landscape photos will not overly influence the total exposure.

⟁ **The AE-1's center-weighted meter rendered this pleasant landscape perfectly in Shutter Priority mode. A relatively slow shutter speed of 1/60 second was chosen by the photographer so that the camera would select a small aperture to maximize depth of field.**

The viewfinder is clear, with an easy-to-read metering scale. The M on the top right blinks when Manual mode is set. The dot below the aperture scale is the underexposure indicator. The bar next to 5.6 indicates how high the needle should rise if the battery is good.

Metering Range

The metering range with an ISO 100 speed film and a lens with a maximum aperture of f/1.4 is from EV 1 to EV 18. This corresponds to exposures ranging from 1 second at f/1.4 to 1/1000 second at f/16.

Automatic Backlight Compensation

On the upper left side of the camera's lens mount are two buttons. The top, chrome one is a small backlight compensation button. (The lower, black one is the exposure preview button, explained later.) Pressing the backlight button adds a correction of +1.5 stops to the exposure computed by the autoexposure system. In other words, the aperture is opened up 1.5 stops wider than would be set normally. This compensates accurately for most backlit situations.

In either Shutter Priority automatic exposure or Manual exposure, it is also possible to compensate for unusual lighting situations like backlighting by setting a different ISO film speed. For example: if you are using film with an ISO speed of 50 and you

The backlight compensation button (top) automatically opens the aperture 1-1/2 stops to compensate for a subject in front of a bright light source. Below is the exposure preview button, which activates the camera's meter without using the shutter release button.

wish to add +1 stop of exposure compensation, you set the film speed dial to 25 rather than 50. This effectively overexposes the image by 1 stop. You must remember to reset the ISO film speed to the standard setting when the adjustment is no longer needed.

Substitute Subject Metering
Subjects of dark or bright color, or unusual reflectance are difficult to meter accurately. In these cases, a KODAK® Gray Card may be very helpful. This card is coated gray to reflect precisely 18% of the light falling on it. The photographer places the gray card in light similar to the light falling on the subject and takes a light meter reading from the gray card. The camera should be held close enough so that the card completely fills the viewfinder frame. Be careful not to cast a shadow on the card. The reading taken in the automatic mode can then be set manually for all photographs made in the same lighting conditions.

Stopped-Down Metering
Non-FD lenses, and accessories such as extension tubes and bellows, do not have the couplings necessary to provide the AE-1 camera with information about the aperture setting. They must be manually metered and set using the stopped-down or working-aperture metering method. This is done using the stop-down lever located on the lower front of the camera body, to the left of the lens mount. When this lever is activated, the lens aperture closes down to the set f/stop. Press the shutter release button halfway or use the exposure preview button to activate the meter. Exposure is then determined by adjusting the aperture or shutter speed until

A fast shutter speed of 1/1000 second was selected in order to freeze the action of this carnival ride and sharply capture its detail.

the meter needle in the viewfinder is aligned with the small battery check index mark on the lower right of the viewfinder. The lever can be locked in position if desired. To release it, press the small button that is exposed when the lever is activated.

Exposure Control

Aperture and Shutter Speed
The AE-1 offers shutter speeds from 1/1000 second to 2 seconds which are set using the shutter speed dial. The available range of apertures is dependent on the lens in use. The AE-1 is designed so that the aperture on FD and FDn lenses can be automatically operated by the camera using a coupling lever on the lens.

Manual Mode

When automatic operation is not desired, the photographer may set both the shutter speed and the aperture manually. The shutter speed is set manually simply by turning the shutter ring to the desired setting. If the lens is set for the automatic position, an aperture may be manually selected by depressing the lock button on the aperture ring and then turning the ring to one of the f/stop settings. An "M" will appear in the viewfinder just above the scale showing the range of apertures. This indicates that the camera is set for manual operation.

Shutter Priority Mode

The Canon AE-1 also offers automatic exposure control in Shutter Priority mode. This means that the user sets the shutter speed desired and the camera selects the corresponding lens aperture for the correct exposure. All lenses with FD or FDn mounts can be used in Shutter Priority mode. The aperture ring of these lenses must be set to the automatic position, which is either marked with a green "A" or, on some lenses, with a green "O" mark. The desired shutter speed is set on the camera body. The photographer can tell by looking through the viewfinder what aperture is selected automatically by the camera.

On looking through the viewfinder of the AE-1 you will see on the far right, just outside of the image area, a scale showing aperture numbers starting at the bottom at f/1.2 and going up to the top to f/22. A moving meter needle indicates the aperture chosen by the camera. If the needle goes beyond the range of the marked apertures this indicates that it is impossible to take pictures at that particular shutter speed setting. A different shutter speed should be selected in order to bring the needle within the range of apertures offered by the lens in use.

Lens Compatibility

Both the original FD lenses with a chrome mounting ring and the later FDn lenses with a black ring work properly on the AE-1 in Shutter Priority and Manual modes. The only difference between the two is that the older FD lenses are set straight on the camera (aligning the red dots), then the chrome ring is turned to lock the

lens on; for the later lenses, with the black ring at the rear, the lens is pushed straight onto the camera's lens mount (again, aligning the dots) and the entire lens is turned to lock it in place. The older FD lenses with the chrome ring are removed from the camera by simply turning the chrome ring counterclockwise and lifting the lens away from the camera. The newer FDn lenses, which are all black, are removed from the camera by pressing the chrome release button on the lens, turning the entire lens counterclockwise and then removing the lens from the camera. Both types of lenses will couple with the light metering system of the AE-1 and can be used in automatic Shutter Priority mode by simply setting the aperture ring on the lens to the "A" or "O" for automatic position.

Shutter Priority autoexposure mode will not work with Canon's earlier FL lenses or with mirror reflex lenses. Because these lenses do not have the couplings necessary to provide the AE-1 camera with information about the lens opening, they must be manually metered and set using the stopped-down or working aperture metering method described on page 19.

Using Electronic Flash

The Canon AE-1 has both a hot shoe and a PC terminal for connecting an electronic flash unit. The hot shoe features a central contact which triggers the flash, including those from other manufacturers. Two additional dedicated contacts are Canon-specific and relay information between electronic flash units made by Canon for the AE-1 camera. The PC terminal connects the camera and flash via a standard PC cord allowing the photographer to position the flash off-camera or use studio strobe units.

Flash Metering

In normal operation, the light metering system of the AE-1 measures through the lens with light reflected from the reflex mirror to the focusing screen. However, when using a dedicated flash unit, the flash metering is done by the flash unit itself, not the camera. Light is reflected from the subject back to a sensor in the flash unit. This shuts off the flash tube when sufficient light has reached the subject. Surprisingly, the camera does not provide TTL OTF metering. (TTL stands for Through The Lens and OTF stands for Off The

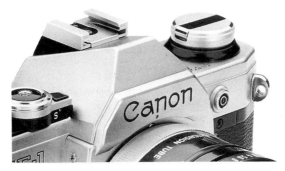

For flash synchronization, the AE-1 has both a hot shoe on top of the prism and a PC terminal on the front of the camera below the film rewind knob.

Film.) In this particular type of flash metering, light passing through the lens striking the film is reflected to a sensor inside the mirror chamber of the camera. This sensor provides information that causes the flash to shut off once proper exposure has been achieved. This is an extremely accurate type of flash metering that was first developed and patented by Canon, but not used in their own cameras until much later, after all of the other major firms had adopted it.

Dedicated Flash Photography
Canon Speedlight flash units in the A, G or T series are "dedicated," which means they can transmit and receive certain information to and from the camera. These flash units produce fully automatic flash exposure when used with the AE-1 and FD lenses, assuming of course that the FD lens' aperture ring is set in the automatic position. Whenever the flash is mounted and fully charged, it will automatically set the synchronization speed on the camera to 1/60 second. Once the photographer selects an aperture on the flash unit for the subject distance range, it will be relayed to the lens by the automatic system. When the flash is fired, the exposure is determined by a sensor on the front of the flash unit.

Canon T-series flash units can be used in a variant of automatic exposure. With these flashes the automatic system does not set synchronization automatically.

Other manufacturers such as Vivitar® and Sunpak® made flash units that were dedicated for use with the Canon AE-1; these are operated in the same manner as described above. Many of these flash units can be found on the used equipment market; your

camera dealer can advise you if a flash unit is suitable for use on the AE-1.

Non-Dedicated Flash Units
Flashes not dedicated for use with the AE-1 system may still be used with the camera. In such cases the camera must be set to 1/60 second or slower and the aperture setting made manually.

Flash Bulbs
Although they are rarely encountered today, flash bulbs can be used with Canon AE-1 cameras. If you are using type FP, MF or M flash bulbs, 1/30 second is the fastest shutter speed you can use on the AE-1 camera. Naturally, with flash bulbs there is no automatic flash operation.

Additional Features

The "B" Setting
The "B," also called Bulb, setting on the shutter speed dial allows the photographer to manually time long exposures. When the shutter speed dial is set to the "B" position, the shutter will remain open as long as pressure is maintained on the shutter release button. Naturally, in the "B" position automatic light metering is not possible.

Self-Timer
The self-timer is activated by moving the locking ring surrounding the shutter release forward to the "S" position. This also uncovers a red LED on the top of the camera. When set this way, the shutter release will be delayed approximately ten seconds from the time that the shutter release button is pressed. During that ten second delay, the red LED will flash to indicate that the self-timer is in operation. Toward the end of the self-timer sequence, the LED will flash more rapidly, and then the shutter will fire.

Depth of Field Preview
Depth of field preview makes it possible to see in the viewfinder what areas will be sharp in the final photograph. This is accomplished by stopping down the lens to the aperture that will be used to make the exposure. The stop-down lever is found on the front

of the camera to the left of the lens mount and must be pushed in toward the lens for operation. It may be used only when the lens aperture is set to a specific f/stop and does not work when the aperture ring is locked in the automatic setting. The lever can be locked in position if desired. To release it, press the small button that is exposed when the lever is activated.

Exposure Preview Button
The exposure preview button is on the left side of the lens mount below the backlight compensation button. Pressing it activates the meter. This can also be accomplished by pressing the shutter release button down halfway.

Multiple Exposures
Although originally not intended for multiple exposures, the AE-1 camera can produce multiple exposure photographs. Take the first exposure normally, then, before winding the film forward, take the slack up with the rewind crank, press in on the film release button on the bottom of the camera while holding the rewind crank, and wind the film in the normal manner. This cocks the shutter mechanism without actually advancing the film. However, because the camera was not originally designed for multiple exposures, the frame counter will advance each time the shutter cocking lever is moved and it is possible that the film will shift very slightly. Therefore, this method is fine for creative or experimental effects but impractical for multiple exposure where exact registration is critical.

Film Plane Indicator
A small circle with a line through it on the right of the rewind knob shows the exact position of the film plane inside the camera. This is useful in certain types of macro and photomicrography when the distance from the film to the subject must be precisely determined.

AE-1 Accessories
The Canon AE-1 accepts the Winder A and A2 for motorized film transport, and the Databack A, which adds the date to pictures during exposure. Eyesight correction (diopter) lenses are also available for the viewfinder eyepiece.

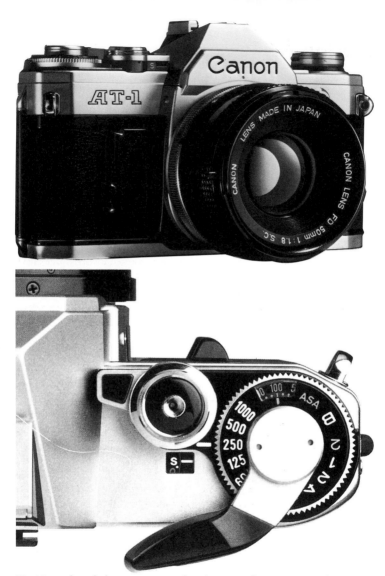

(Top) Introduced about one year after the AE-1, the Canon AT-1 is a manual exposure, electronic camera with nearly the same body design as its predecessor. (Bottom) The shutter release with self-timer lever, and the shutter speed dial surrounding the film advance lever are on the top right of the AT-1. A window in the shutter speed dial shows the ISO/ASA speed that has been set.

Canon AT-1

In 1976 Leica began production of the R3, the flagship camera in its new series of SLRs that were electronically-controlled and based somewhat on the Minolta XE-1. Pentax continued with the K series and joined the trend toward miniaturization by introducing the M-series bayonet-mount camera. Nikon continued its SLR camera development program with the Nikon FM and introduced the AI-type lenses which made lens coupling to the camera body much simpler. But the front runner was definitely the Canon AE-1 automatic camera. Because of the great success of the Canon AE-1, Canon decided to continue developing new cameras based on the same body. In 1977 the next camera in the Canon program, the AT-1 was introduced. The AT-1 is essentially identical to the AE-1, but lacks automatic exposure operation, featuring manual exposure metering instead.

Basic Camera Operation

Except for the absence of Shutter Priority autoexposure, the AT-1's operating features are similar to the Canon AE-1 and are covered in the AE-1 chapter. This should be read before proceeding with the differences which are detailed below.

The Viewfinder
The view through the eyepiece in the AT-1 appears on a very fine grain focusing screen. In the center of the screen is a focusing aid that combines a circle with a microprism engraving, with a split image rangefinder in the center of that. This allows for easy focusing on almost all types of subjects. To the right of the focusing screen, you can see the aperture/shutter speed follower needle with a circle on the end of it and the meter needle, which is a simple straight black needle.

The Battery
Battery operations and recommendations are the same as with the

AE-1 camera except that the AT-1's metering system is more sensitive to battery voltage fluctuations. It may not meter properly if used with an alkaline battery. Thus, only the PX-28 silver oxide or lithium versions are recommended for use in this camera.

After installation, check the battery's operation with the battery test. Do this by rotating the lever that is concentric with the rewind crank clockwise until the index mark on its front lines up with a black C on the camera's top deck. Look through the viewfinder while doing this and make sure that the moving meter needle goes up above the upper index mark. Check the battery often. If the battery fails, the shutter will be inoperable.

Lens Compatibility

FL lenses and mirror reflex lenses: Because these lenses do not have the couplings necessary to provide the AT-1 camera with information about lens opening, they must be set manually and metered by the stopped-down method. (See page 31.)

FD and FDn lenses: Both the original FD lenses with the chrome attaching ring and the later FDn lenses with the black attaching ring work properly for open aperture metering on the AT-1. This also includes Canon FD-mount lenses manufactured by non-OEM vendors such as Vivitar®, Tamron®, Kiron®, Sigma®, Pro®, Quantaray®, etc. Since these are often available on the used camera market, many good lenses can be purchased at an economical price. For advice on compatibility of specific lenses, see your specialty camera dealer.

The Light Meter

The AT-1 camera has a center-weighted integrated meter, which means that the major emphasis of the exposure is given to the central part of the image. The upper part of the image is given less priority so that bright sky in landscape photos will not overly influence the exposure.

The AT-1 uses a match-needle metering system. The straight needle responds to the light level. The follower needle with a circle on the end moves as the settings are changed. Recommended exposure is set when the two needles align, as shown here.

Metering Range

The metering range with 100 speed film and a lens with a maximum aperture of f/1.4 is from EV 3 to EV 18. This corresponds to exposures ranging from 1/4 second at f/1.4 to 1/1000 second at f/16.

Using the Light Meter

While the Canon AE-1 offers automatic exposure in Shutter Priority mode, the AT-1 features only Manual mode with manual, match-needle metering. The light meter is turned on by rotating the ring on the top left of the camera counter-clockwise until the index mark on the ring lines up with the "ON" designation. Always remember to switch the meter off when not in use to prevent battery drain.

Metering Available Light

The AT-1 is designed so that the aperture on the FD and FDn type lenses automatically couples with the camera. As the aperture ring on the lens or the shutter speed dial on the camera is turned, a black indicator needle with a circle on the end moves vertically along the right-hand edge of the viewfinder. This indicator needle is called a "follower needle."

A straight black metering needle moves in response to the level of light detected by the camera's meter. By changing the aperture opening or shutter speed (or both) the follower needle is aligned with the black meter needle and the camera is set for correct exposure. The shutter speed may be set from 1/1000 second to 2 seconds; the available range of apertures depends on the lens in use.

Stopped-Down Metering

Non-FD lenses, and accessories such as extension tubes and bellows, do not have the couplings necessary to provide the AT-1 camera with information about the aperture setting. They must be manually metered and set using the stopped-down or working-aperture metering method. This is done using the stop-down lever located on the lower front of the camera body to the left of the lens mount. When this lever is activated, the lens aperture closes down to the f/stop setting. Exposure is determined by adjusting the aperture or shutter speed until the meter needle in the viewfinder is aligned with the small index mark on the lower right of the viewfinder. The lever can be locked in position if desired. To release it, press the small button that is exposed when the lever is activated.

Automatic Backlight Compensation

Because it has no autoexposure mode, the AT-1 lacks a backlight compensation button. Instead, exposure compensation can be set by simply selecting a shutter speed or aperture other than what the meter recommends. It is also possible to compensate for unusual lighting situations by setting a film speed other than the rated ISO speed of the film. For example: if you are using film with an ISO speed of 100 to photograph a person in front of a window and you wish to have a +1 compensation, you would set the film speed dial to 50 rather than 100. This effectively adds 1 stop of exposure compensation to properly expose the backlit subject.

Substitute Subject Metering

Under certain circumstances such as backlighting or with subjects of unusual reflectance, it is difficult to get an accurate light meter reading. In these cases a KODAK® Gray Card may be very helpful. A gray card is simply a piece of cardboard that has been colored gray to reflect precisely 18% of the light falling on it. The photographer places the gray card in light similar to the light

The author metered the darker area in the lower part of the scene in order to reveal detail in the submerged boat. Using a Polarizing filter reduced surface glare on the water.

According to the camera's meter, this photograph would have been overexposed. However, to compensate for the bright background and snow, the photographer correctly opened the lens one stop more than the meter's recommendation.

falling on the subject and takes a light meter reading from the gray card with the camera close enough so that nothing but the gray card appears within the viewfinder. This reading taken off the gray card can be used for all photographs of subjects under the same lighting conditions.

Using Flash with the AT-1

Dedicated Flash Photography

The Canon AT-1 is fitted with a hot shoe with a central contact and one additional contact that links directly to electronic flash units made by Canon for use with A-series cameras. These flash units in the Speedlight A- or G-series are dedicated, which means information can be relayed by the hot-shoe contacts between the

Shutter speeds from 2 seconds to 1/1000 second are available on the AT-1 as well as a bulb setting for longer, manually-timed exposures. The flash synchronization speed of 1/60 second is marked with a lightning-bolt symbol. The knurled edge of the dial makes it easier to turn for setting the shutter speed and to lift and turn for setting the film speed.

camera and flash. Whenever the flash is mounted and fully charged it will automatically set the synchronization speed on the camera to 1/60 second, which is the fastest shutter speed at which the AT-1 can be used with flash.

When used with the AT-1 and FD lenses, these particular flash units can produce fully automatic computerized exposure. The flash exposure will be determined by the sensor on the front of the flash unit. The sensor shuts off the flash tube when sufficient light has reached the subject. While generally quite effective, such systems can be fooled by subjects with greater or lesser overall reflectance than the 12 to 21% average for which these systems are calibrated.

Canon Speedlites in the T-series may be used with a variant of automatic exposure. These flash units do not set the AT-1's flash synchronization automatically.

Note: Non-OEM manufacturers such as Sunpak® or Vivitar® manufactured flash units with Canon "A" dedication. A knowledgeable photo dealer can advise you on the purchase of such flash units, which may be available on the used equipment market.

Non-Dedicated Flash Units
Flash units that are not made by Canon or dedicated for use with the A-series camera system can still be used with the camera. However, the camera must be set to the flash synchronization speed of 1/60 second or slower and the aperture setting made manually.

Flash Bulbs
Although they are rarely encountered today, flash bulbs can be used with Canon AT-1 cameras. If you are using type FP, MF or M flash bulbs, 1/30 second is the fastest shutter speed you can use with the AT-1. Naturally, with flash bulbs there is no automatic flash operation.

Additional Features

The "B" Setting
When the shutter speed dial is set to the "B" position, the shutter will remain open as long as pressure is maintained on the shutter release button. Naturally, light metering is not possible with the "B" setting.

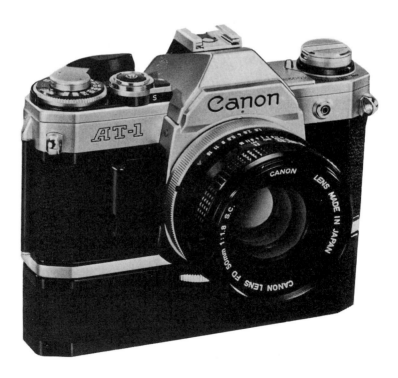

Self-Timer
When the lever surrounding the shutter release button is moved forward to the "S" position, this activates the self-timer. This also exposes a red LED on the top of the camera. When set this way, the shutter release will be delayed approximately ten seconds from the time that the shutter release button is pressed. During that ten second delay, the red LED will flash to indicate that the self-timer is in operation. Toward the end of the self-timer sequence, the LED will flash more rapidly, and then the shutter will fire.

Depth of Field Preview
The depth of field preview makes it possible to see through the view finder what areas will be sharp and unsharp by stopping down the lens' aperture to the actual taking position. The depth of field preview lever is found on the left side of the camera lens mount and must be pushed in toward the lens for operation. It is also used for stopped-down metering with non-FD lenses and accessories, see page 31.

Canon Accessories
The AT-1 can be used with the Winder A and A2 for fast action pictures, and also with the Databack A, which allows the date to be printed on the pictures during exposure. Eyesight correction lenses (diopters) were also manufactured for the camera's view-finder eyepiece.

The Canon AT-1 with the Canon Winder A

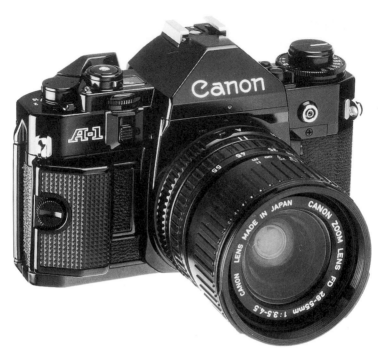

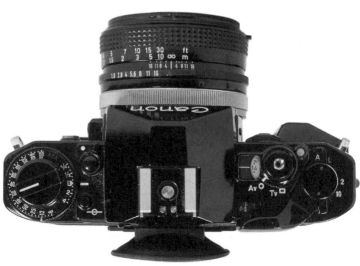

Canon A-1

By 1977 and 1978 a number of camera companies had developed prototypes of cameras with dual automation; however, none of them had brought such a camera to market. These cameras offered both Shutter Priority and Aperture Priority autoexposure modes. With its XD-7, Minolta was the first company to actually produce such a camera. Meanwhile, Praktica introduced the EE2 with automatic light metering; Yashica produced models FR1 and FR2, again advancing automatic light metering; Konica produced the T4 using Konica's own version of Shutter Priority automation. And then the Canon A-1 appeared, bringing a new multi-automatic SLR to the field.

The A-1 is the top model of the Canon A series. Designed for professional and semi-professional use and built to very high standards of quality, it was based on the same basic body design as the AE-1 and AT-1. Canon's multi-automation for the first time offered a camera with Shutter Priority, Aperture Priority and Program exposure modes, as well as full manual control. In Shutter Priority mode, the photographer picks the desired shutter speed and the camera selects the proper aperture opening. In Aperture Priority, the photographer chooses the desired aperture and the camera picks the appropriate shutter speed for correct exposure. In Program mode, the camera chooses both aperture and shutter speed.

↶ **(Top) A revolutionary camera at the time of its introduction, the Canon A-1 was Canon's first multi-mode, electronic SLR. (Bottom) The top of the A-1 camera features (left to right) the ISO/ASA and exposure compensation dial surrounding the film rewind assembly, the lock-release button for this dial is to the right, the battery check button (front) with the viewfinder display switch on its collar, hot shoe with dedicated flash contacts, shutter release with mode selector, the frame counter, and four-position on, off, 2- and 10-second self-timer switch surrounding the film advance lever.**

Basic Camera Operation

The Main Switch
The A-1's main switch is located around the hub of the film advance lever. This lever protrudes toward the front and has four positions. When pointing forward, the lever lines up with a large A, which indicates the camera is on. Moving it clockwise by one click lines it up with a large L, and in this position the camera is locked and will not fire. Clockwise from this position is one marked with the number 2, and the final position is marked with the number 10. These two positions set the self-timer for either a two-second or a ten-second delay. See also, page 51.

The Mode Selector
Located to the left of the film advance lever, the mode selector sets the camera's operating mode. Select "Tv" for Shutter Priority, Program or Manual operation. When in this position, shutter speeds or "P" for program can be selected on the black scale under the window to the left. In the "Av" position the camera is set for Aperture Priority automatic and an aperture scale appears in the window.

Installing the Battery
To access the battery compartment on the A-1 camera you must first remove the hand grip. Use a coin or screwdriver to loosen the screw on the grip, then slide the grip off toward the left (looking at the front of the camera). Once the grip is removed, open the battery compartment on the right front side of the A-1 by pressing the small recessed tab on the lower left corner and swinging the battery compartment cover up toward the lens. Then insert the 6-volt battery with the plus pole upward.

The correct battery is a silver oxide battery type PX 28 or an equivalent lithium or alkaline-manganese battery. After installation, check the battery's operation with the battery test button.

In order to make the dark clouds appear even more imposing, the author set a slight minus compensation on the A-1 for this famous Cologne landmark photographed during Photokina.

You will find this on the left side of the camera body, at the front, surrounded by a collar with a short lever on it. When the battery is properly installed and in proper operating condition, pressing the button will cause the red LED just in front of the shutter release button to flash. Check the battery often. If the battery fails, the camera shutter will be inoperable.

Loading the Film

Open the camera back by pulling up on the rewind knob. Take the end of the film and fit it into one of the slots in the take-up spool then insert the cassette into the left side of the camera, making sure that it fits properly onto the forked shaft of the rewind crank. Advance the film with the film advance lever until you are certain that it will not slip out of the take-up spool, then close the camera back. Turn the rewind crank in the direction of the arrow until the slack has been taken up, and advance the film through two blank exposures. Watch the rewind crank to make sure it turns showing that film is actually moving through the camera.

Caution: While loading the film be careful not to touch the shutter. The shutter curtains are very delicate.

Film Transport

For convenience, an internal ratchet allows the film to be advanced with one long or several short motions of the film advance lever. The frame number is shown in the frame counter window located just to the right of the prism hump on the rear of the top deck. The film may also be transported with the Winder A or A2, for fast operation, or with the Motor Drive MA, for higher speed advance. When the film winder or motordrive is attached, the film advance lever should be positioned inward as far as it goes. While the winders only get up to two frames per second, the Motor Drive MA can run at five frames per second, fast even by today's standards. This much speed has a price, though, since the motor requires twelve AA cells and is consequently quite heavy.

Rewinding the Film

When the film will not advance any further and the shutter will not fire you are at the end of the roll. To rewind the film you must press in on the film rewind release button on the bottom of the

camera (or on the bottom of the motor winder, if attached) and turn the film rewind knob with its folding crank on the left end of the camera. You will know when you are completely rewound because the slight resistance caused by the film being pulled through the mechanism will cease and the rewind crank will turn more freely. You can then easily remove the film cartridge by pulling up on the rewind knob and opening the back again. This also resets the frame counter to the S (start) position.

Setting the Film Speed
A large dial concentric with the rewind knob acts as the film speed setting dial. To set the film speed you must lift up slightly on the outer rim of this dial and rotate the dial until the desired film speed is aligned with a white index mark on the rotating dial rim. By doing this you can set speeds from ISO 6 up to ISO 12,800, a remarkably wide range for any camera. The same dial allows you to set exposure compensation in 1/3 step increments from +2 to -2 steps. It is marked, however, in an odd manner that indicates one stop overexposure by a 2 and two steps overexposure by a 4. Similarly it indicates one step underexposure by 1/2 and two steps underexposure by 1/4. This numbering system represents the fact that adding one stop is doubling the amount of light and subtracting one stop is halving the amount of light.

To make these settings, press the battery test button, which doubles as a release, and rotate the entire dial without pulling up on the rim to align the desired exposure factor with the white index mark on the camera body.

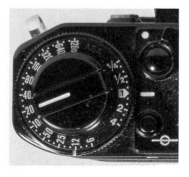

On the top left side of the camera are the controls for film speed and exposure compensation. There is also the release for the camera back, the film rewind crank, battery check, the on/off switch for the viewfinder illuminator, and the film plane indicator.

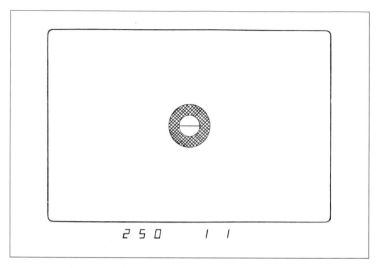

The viewfinder of the A-1 was the first to display information in a digital format. The shutter speed and aperture set on the camera appear in the bottom of the viewfinder outside the image area.

The Viewfinder

The view through the eyepiece in the A-1 appears on a very fine grain focusing screen. In the center of the screen is a focusing aid that combines a circle with a microprism or Dodin prism engraving, with a split-image rangefinder in the center of that. This allows for easy focusing on almost all types of subjects. Although the screen can't be changed by the user, Canon service personnel can install any of the several optional screens offered.

The Canon A-1 was the first Canon camera to feature fully digital information inside the viewfinder. Today we take this for granted, but in 1978 it was really spectacular. The bright red LED readout inside the viewfinder under the image area shows the selected shutter speed on the left and the selected aperture on the right. The information is visible in just about any situation, which is an advantage when shooting in a darkened area like a theater or during a nighttime sporting event.

Viewfinder Display Illuminator

Additionally, on the top left deck of the camera, around the battery test button, is a collar with a short lever. If this lever is moved to the right, uncovering a white dot, the display in the viewfinder will be illuminated when the shutter release button is pressed half way or when either the AE lock or Viewfinder Display button is pressed. If this lever is moved to the left covering the white dot, the display is shut off but the camera is still fully functional. This position may be used to conserve battery power.

Lens Compatibility

Canon FL lenses and mirror reflex lenses: Because these lenses do not have the couplings necessary to provide the A-1 camera with information about the lens opening, they must be set manually and metering must be done using the stopped-down metering method.

Canon FD and FDn lenses: Both the original FD lenses with the chrome attaching ring and the later FDn lenses with the black attaching ring work properly on the A-1. The only difference between the two is that the older FD lenses fit onto the camera, then the chrome ring is turned to lock the lens in place; for the later lenses, with the black ring at the rear, the lens is pushed straight onto the camera and the entire lens is turned to lock it in place. The older FD lenses with the chrome ring are removed from the camera by simply turning the chrome ring counterclockwise and lifting the lens away from the camera. The newer FDn lenses, which are all black, are removed from the camera by pressing the chrome release button on the lens, turning the entire lens counterclockwise and then removing the lens from the camera. Both types of lenses will couple with the light metering system of the A-1.

The Light Meter

The light metering system of the A-1 measures light that enters the camera through the lens and is reflected from the reflex mirror to the focusing screen. The camera has a center-weighted integrated

This mid-toned scene is a perfect subject for the A-1 camera's center-weighted meter.

meter, which means that the major emphasis of the exposure is given to the central part of the image. The upper part of the image is given less priority so that bright sky in landscape photos will not overly influence the overall exposure.

Metering Range
The metering range with an ISO 100 speed film and a lens with a maximum aperture of f/1.4 is from EV - 2 to EV 18. This corresponds to exposures ranging from 8 second at f/1.4 to 1/1000 second at f/16.

Exposure Preview Button
On the left side of the camera near the lens mount are two small buttons. The lower one with the chrome rim is the exposure preview button used to activate the meter. This can also be done by partially depressing the shutter release button. However, using the

Exposure mode is set on a collar switch around the shutter release button. In this photo the camera is set for Aperture Priority and the f/stops appear in the window to the left. If the camera were set for "Tv," Shutter Priority, shutter speeds would be seen in the window. In Program mode, the switch would be set at "Tv," but the window would show a "P" instead of a shutter speed.

exposure preview button will not accidently trip the shutter and waste an exposure.

Autoexposure Lock Button

The upper button on the left side of the camera near the lens mount is the AE lock button. It turns on the display and, at the same time, retains the exposure reading. This is useful when you wish to take a light meter reading from one area and then recompose the image before taking the photograph.

Substitute Subject Metering

Under certain circumstances it is very difficult to get an accurate light meter reading. In such cases, a KODAK® Gray Card may be very helpful. This is a carefully coated piece of cardboard that has been colored gray to reflect precisely 18% of the light falling on it. The photographer places the gray card in light similar to the light falling on the subject and takes a light meter reading from the gray card with the camera close enough so that nothing but the gray card appears within the viewfinder. This reading taken in the automatic setting can then be remembered and set manually, or held with the AE lock button for all photographs of that subject under that particular lighting.

Stopped-Down Metering

Non-FD lenses and accessories do not have the couplings necessary to provide the A-1 camera with information about the aperture setting; they must be manually metered and set using the

On the lower front of the camera near the lens mount is the stop-down lever. It can be used to preview the depth of field of a set aperture or for stopped-down metering. Above the stop-down lever is the exposure preview button and above that is the auto-exposure lock button. On the front of the camera towards the top is the PC terminal.

stopped-down or working aperture method. This is done using the depth of field lever located on the lower front of the camera body to the left of the lens mount. When this lever is activated, the lens aperture closes down to the set f/stop. Using manual metering, the proper aperture setting can be determined and set. The depth of field lever can be locked in position if desired. To release it, press the small button that is exposed when the lever is activated.

Exposure Control

Aperture and Shutter Speed

The A-1 is designed so that the diaphragm on the FD and FDn lenses can be automatically operated from the camera by means of a coupling lever. The camera shutter may be set from 1/1000 second to 30 seconds, while the available range of apertures depends on the lens in use.

Shutter Priority Mode

The A-1 offers a variety of exposure mode options. First, like the AE-1, it may be used in Shutter Priority mode, which Canon calls Tv for Time Value. The Tv mode is set by turning a ring concentric with the shutter release button. When this is done, the window on the top of the camera will display shutter speeds only, and you may use the rotating dial that protrudes from the front of the camera to set the desired speed. If the lens is set properly to the automatic position on the aperture ring, the camera will then pick the correct lens opening to match the shutter speed you have selected. Both shutter speed and aperture are visible inside the viewfinder in a bright red digital display under the image area.

Aperture Priority Mode

The second exposure mode is Aperture Priority, which Canon calls Av for Aperture Value. To select this, turn the ring around the shutter release button to the Av position. When this is done, the window on top of the camera displays aperture values only, and the protruding dial may be used to select the desired aperture. The lens aperture ring is *not* used, and is left in its automatic position. Again, both shutter speed and aperture are displayed in the viewfinder.

Program Mode

The third exposure mode is Program. To access this mode, make sure the lens aperture ring is set to the automatic position, and the camera in the Tv mode. Then rotate the dial to run through the shutter speed until you see a green P just past the 1000 setting. Line this P up with the index mark, and the camera is set for fully programmed operation. The camera selects both the aperture and shutter speed from a programmed selection which takes factors like the film speed, minimum and maximum aperture of the lens and subject brightness into account .

Manual Mode

The fourth exposure mode is Manual; the photographer selects both shutter speed and aperture. Manual mode is accessed by putting the camera in the Tv mode to select the desired shutter speed, and taking the lens aperture ring from the automatic position to manually select the desired aperture. The meter may be used by

The A-1's metering system gives the top portion of a horizontal image less emphasis. This prevents a bright sky from overwhelming the exposure reading causing the foreground to be underexposed.

noting the aperture indicated in the viewfinder and manually setting it, or by pre-selecting an aperture and setting it on the lens, then rotating the shutter speeds until the pre-selected aperture is displayed.

Using Flash with the A-1

Flash Metering

In normal operation the light metering system of the A-1 measures through the lens with light reflected from the reflex mirror to the focusing screen. However, when using a dedicated flash unit, the flash unit does the metering rather than the camera. Light striking the subject from the flash is reflected back to a sensor coupled to the flash unit's electronic system. The sensor shuts off the flash tube when sufficient light has reached the subject.

Surprisingly, the camera does not provide TTL OTF metering. (TTL stands for "through the lens" and OTF stands for "off the film.") In this particular type of flash metering, light passes through the lens, strikes the film, and is reflected back to a sensor inside the mirror chamber of the camera. This sensor is connected to the flash unit and provides information that causes the flash to shut off once proper exposure has been achieved. This is an extremely accurate type of flash metering first developed and patented by Canon, but not used in their own cameras until much later, after all of the other major firms had adopted it.

Dedicated Flash Photography
Canon Speedlight A-, G- or T-series flash units are dedicated, which means that, when attached to the camera, they automatically set certain functions. These particular flash units produce fully automatic exposure, determined by a sensor on the flash unit, when used with the A-1 and FD lenses, assuming of course that the FD lens is set for automatic aperture selection. Whenever the flash is mounted and is ready for operation it will automatically set the synchronization speed on the camera to 1/60 second, which is the fastest shutter speed at which the A-1 can be used with flash. The light metering will then be done by the sensor of the electronic flash system. All T-series flash units may be used in automatic exposure mode, however, they *do not* set synchronization automatically.

The A-1 has a dedicated hot shoe that not only synchronizes the flash with the shutter release, it also allows A- and G-series flash units to automatically set the camera to its maximum flash sync speed of 1/60 second.

Other manufacturers such as Vivitar® and Sunpak® made flash units that were dedicated for use with the Canon A-1; these are

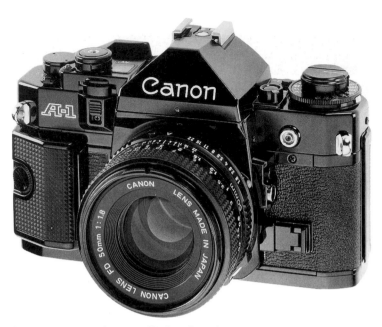

Important controls are well placed on the Canon A-1. On the top left side of the lens mount is the autoexposure lock button with the exposure preview button slightly below it. The depth of field preview lever is easily accessed on the lower left side of the lens mount.

operated in the same manner as described above. These flash units can often be found on the used equipment market; your camera dealer can advise you if a particular flash unit is suitable for use on the A-1.

Non-Dedicated Flash Units

Flash units that are not dedicated for use with A-series cameras can be used with the A-1. With these, the camera must be set to a shutter speed of 1/60 second or slower and the aperture adjusted manually. Follow the instructions for the flash unit to achieve correct exposures with the Canon A-1.

Flash Bulbs

Although rarely used today, flash bulbs will work with Canon A-1 cameras. If you are using type FP, MF or M flash bulbs, 1/30 second is the fastest shutter speed you can use. Naturally, with flash bulbs there is no automatic flash operation.

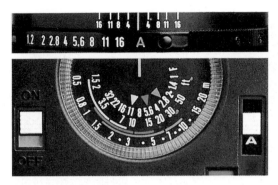

For flash autoexposure with the Speedlite 199A, an FD lens must be used. The photographer has a joice of three exposure ranges (shown on the expose control dial).

Additional Features

Eyepiece Shutter

On the back of the camera, just to the left of the eyepiece, is a small lever; pushing this to the left closes the eyepiece shutter. This should be used whenever the photographer is making an exposure and does not have his or her eye to the eyepiece; it prevents light from entering the eyepiece, causing incorrect meter readings.

The "B" Setting

For exposures longer than 30 seconds, the A-1 also offers the "B," or Bulb, setting. This allows the photographer to manually time long exposures. When the shutter speed dial is set to the "B" position, the shutter will remain open as long as pressure is maintained on the shutter release button. Naturally, in the "B" position automatic light metering is not possible.

Self-Timer

In addition to being an on/off switch, the small lever mounted concentrically on the hub of the film advance lever sets the self-timer. When pointing straight forward, the lever lines up with a large A, which indicates normal camera operation. Moving it clockwise by one click lines it up with a large L, and in this position the camera is locked and will not fire. The next position clockwise is marked with the number 2, and the final position is marked with the number 10. These markings indicate self-timer settings

Flash was used to supplement the ambient light in this photo of a Valentine's Day display.

for either a two-second or a ten-second delay. The self-timer is activated by pressing the shutter release button in the normal way.

Depth of Field Preview
The depth of field preview makes it possible to see what areas will be sharp and unsharp by stopping down the lens' aperture to the actual taking position. The depth of field preview lever is found on the left side of the camera's lens mount and must be pushed in toward the lens for operation. It only operates when the lens is set at the manual aperture setting and is also used for stopped-down metering with non-FD lenses. See page 45.

Multiple Exposures
The Canon A-1 is the first of the Canon A-series cameras to be designed for easy multiple exposure operation. Concentric with

the hub of the film advance lever is a small lever that projects toward the rear of the camera. When this short lever is moved to the left, revealing a red dot underneath, it disengages the film advance gears and allows the shutter to be cocked without simultaneously advancing the film. The lever is automatically returned to the normal position each time the camera is fired and the shutter cocked, but may be re-set any number of times, allowing any number of exposures on a single frame of film. The frame counter does not advance when multiple exposures are made, so it always correctly indicates the actual number of film frames that have been used.

Film Plane Indicator
A small circle with a line through it on the right of the rewind knob shows the exact position of the film plane inside the camera. This is useful in certain types of macro and photomicrography when the distance from the film to the subject must be calculated with precision.

Canon AE-1 Program

Canon added another popular camera to its A-series line-up with the introduction of the AE-1 Program in 1981. Often referred to as the AE-1P, the camera features Shutter Priority and Program auto-exposure modes as well as Manual mode. It also features user-interchangeable focusing screens.

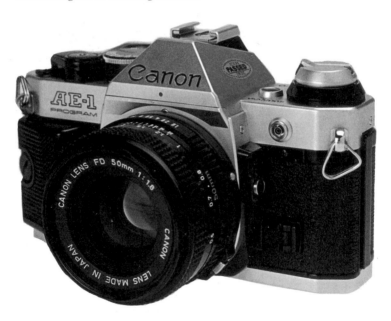

Basic Camera Operation

The Main Switch

The main control switch on the AE-1P is a lever mounted on the hub of the film advance lever. This lever has three positions: the "A" position for normal camera operation, the "L" position which locks the camera so it will not fire, and the "S" position which sets the camera's self-timer for a ten-second delay. See also page 64.

The Shutter Speed Dial

The AE-1 Program's shutter speed dial is used to select the expo-
sure mode as well as shutter speeds. In the PROGRAM position
the camera operates in fully automatic, Program mode. The dial is
turned to select the shutter speed in Shutter Priority and Manual
modes.

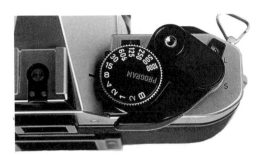

The shutter speed
dial to the left of the
film advance is used
to select the expo-
sure mode and shut-
ter speed. The lever
to the right of the
film advance turns
the camera on (A),
locks the controls
(L), and activates the
self-timer (S).

Installing the Battery

To access the battery compartment on the AE-1P camera you must
first remove the hand grip. Use a coin or screwdriver to loosen
the screw, then slide the grip off. Once the grip is removed, open
the battery compartment on the right front side of the camera by
pressing the small recessed tab on the lower left corner and swing-
ing the battery compartment cover up toward the lens. Then insert

To insert the battery,
loosen the hand grip
with a coin or screw-
driver and slide it
off. Press the small,
recessed tab on the
lower left of the bat-
tery compartment
door to open the
battery compart-
ment.

the 6-volt battery with the plus pole upward. The correct battery is a PX 28 silver oxide battery or an equivalent lithium or alkaline-manganese battery.

Battery check: After installation, check the battery operation with the battery test button. You will find this on the left side of the camera body, at the front, surrounded by a collar with a short lever on it. When the battery is properly installed and in proper operating condition, pressing the button will cause the red LED just in front of the shutter release button to flash. Check the battery often. If the battery fails, the camera systems will be inoperable.

Loading the Film

Open the camera back by pulling up on the rewind knob. Take the end of the film and fit it into one of the slots in the take-up spool then insert the cassette into the left side of the camera, making sure that it fits properly onto the forked shaft of the rewind crank. Advance the film with the film advance lever until you are certain that it will not slip out of the take-up spool, then close the camera back. Once the camera back has been closed, turn the rewind crank in the direction of the arrow until the slack has been taken up, and advance the film through two blank exposures.

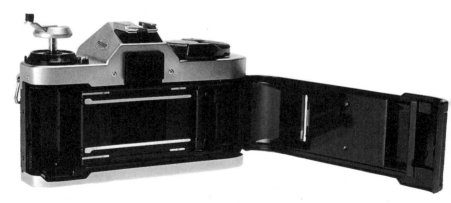

Loading film is easy with the AE-1P. Open the camera back by lifting up on the rewind knob. The film cassette fits in the compartment on the left, and the film is threaded into the slotted spool on the right. On the inside of the camera back is the pressure plate, which keeps the film perfectly flat for sharp photographs.

Watch the rewind crank to make sure it turns, showing that film is actually moving through the camera.

Caution: While loading the film, be very careful not to touch the shutter. The shutter curtains are delicate.

Film Transport
For convenience, an internal ratchet allows the film to be advanced with one long or several short motions of the film advance lever. The frame number is shown in the frame counter window located just to the front of the shutter speed dial. The film may also be transported with the Winder A or A2, for fast operation, or with the Motor Drive MA, for higher speed advance. When the winder or motor drive is attached, the film advance lever should be stowed inward as far as it goes. While the winders only get up to two frames per second, the Motor Drive MA can run at five frames per second, fast even by today's standards. This much speed has a price, though, since the motor requires twelve AA cells and is, consequently, quite heavy.

Rewinding the Film
When the film will not advance any further and the shutter will not fire, you are at the end of the roll. To rewind the film you must press in on the film rewind release button on the bottom of the camera (or on the bottom of the motor winder, if attached) and use the film rewind knob with its folding crank on the left end of the camera. You will know when the film is completely rewound because the slight resistance caused by the film being pulled through the mechanism will cease and the rewind crank will turn more freely. You can then easily remove the film cartridge by pulling up on the rewind knob and opening the back again. This also resets the frame counter to the S (start) position.

Setting the Film Speed
The AE-1 Program's film speed scale is located on the left top of the camera under the rewind knob. To set the film speed, depress the lock button on the collar and turn the small lever to rotate the dial until the desired film speed is aligned with the green index mark on the rim and it clicks into place. You can set speeds from ISO 12 up to ISO 3200.

On the top left of the AE-1 Program is the film speed selector lever. The silver lock release button is located toward the rear. The black battery check button is located under the serial number.

The Viewfinder

New out of the box, the AE-1P featured a very bright, fine-grain focusing screen. In the center of this screen is a focusing aid with a split-image rangefinder surrounded by an outer circle with a microprism engraving. This allows for easy focusing on almost all types of subjects.

The Canon AE-1P features LED numbers on the right side of the viewfinder; these illuminate to indicate the aperture selection. Above the aperture numbers is an M which indicates that the lens is in Manual mode and a P to indicate that Program mode has been selected. The P also blinks in Program mode when the camera selects a shutter speed slower than 1/30 second to remind the photographer to use a tripod. When the smallest or largest aperture number blinks, the camera is warning of under- or overexposure. The flash symbol on the lower right below the aperture numbers indicates flash-ready status. The information is visible in just about any situation, which is an advantage when shooting in a darkened area such as a theater or during a nighttime sporting event.

Changing the Focusing Screen

Canon designed the AE-1P so that its focusing screens could be easily changed and replaced by an accessory A-series screen. When the AE-1P was part of its equipment list, Canon offered eight different focusing screens for the camera. These included: Matte with Grid, Double Cross-Hair Reticle, Matte Scale and Cross Split Image. To change the screen, simply remove the lens and press upward on the small black release tab in the top center of the camera's mirror box. The focusing screen assembly will drop

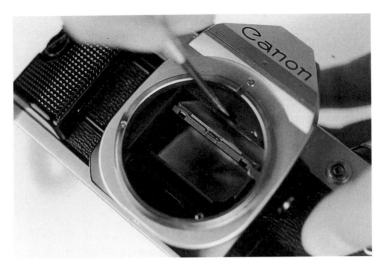

To remove the AE-1P's focusing screen, press upward on the release tab in the top center of the camera's mirror box.

downward. Using a tweezers or by hand without touching the glass, remove the screen from the camera. Carefully position the new focusing screen and gently press until it locks in place.

Caution: Never touch the focusing screen or the camera's delicate front-surface mirror. Dirt or oil from fingers can cause permanent damage!

Lens Compatibility

Canon FL lenses and mirror reflex lenses: Because these lenses do not have the couplings necessary to provide the AE-1P camera with information about the lens opening, they must be set manually and metering must be done using the stopped-down method, see page 61.

Canon FD and FDn lenses: Both the original FD lenses with the chrome attaching ring and the later FDn lenses with the black attaching ring work properly on the AE-1P. The only difference

between the two is that older FD lenses fit onto the camera, then the chrome ring is turned to lock the lens in place; for the later lenses, with the black ring at the rear, the lens is pushed onto the camera and the entire lens is turned to lock it in place. The older FD lenses with the chrome ring are removed from the camera by simply turning the chrome ring counter clockwise and lifting the lens away from the camera. The newer FDn lenses, which are all black, are removed from the camera by pressing the chrome release button on the lens, turning the entire lens counter clockwise and then removing the lens from the camera. Both types of FD lenses will couple with the light metering system of the AE-1P.

The Light Meter

The light metering system of the AE-1P measures light that enters the camera through the lens and is reflected from the reflex mirror to the focusing screen. The camera has a center-weighted integrated meter, which means that the major emphasis of the exposure is given to the central part of the image. The upper part of the image is given less priority so that bright sky in landscape photos will not overly influence the overall exposure.

Metering Range
The metering range with an ISO 100 speed film and a lens with a maximum aperture of f/1.4 is from EV 1 to EV 18. This corresponds to exposures ranging from 1 second at f/1.4 to 1/1000 second at f/16.

Exposure Preview Button
On the left side of the camera's lens mount are two small buttons. The lower one with the chrome rim is the exposure preview button used to activate the meter. This can also be done by partially depressing the shutter release button. However, using the exposure preview button will not accidently trip the shutter and waste an exposure.

Autoexposure Lock Button
The upper button on the left side of the camera's lens mount is the AE lock button. It turns on the viewfinder display and at the same

time, in the automatic modes, retains the exposure reading. This is useful when you wish to take a light meter reading from one area (such as up close on a person's face when there is backlighting) and then recompose the image before taking the photograph.

Substitute Subject Metering
Under certain circumstances it is very difficult to get an accurate light meter reading. In such cases, a KODAK® Gray Card may be very helpful. This is a carefully coated piece of cardboard that has been colored gray to reflect precisely 18% of the light falling on it. The photographer places the gray card in light similar to the light falling on the subject and takes a light meter reading from the gray card with the camera close enough so that nothing but the gray card appears within the viewfinder. This reading taken in the automatic setting can then be remembered and set manually, or held with the AE lock button (as mentioned above) for all photographs of the subject under that particular lighting.

Stopped-Down Metering
Non-FD lenses and accessories do not have the couplings necessary to provide the AE-1P camera with information about the aperture setting; they must be manually metered and set using the stopped-down or working aperture method. This is done by operating the depth of field lever located on the lower front of the camera body to the left of the lens mount. When this lever is activated, the lens aperture closes down to the f/stop setting. By using manual metering, the proper aperture setting can be determined and set. The lever can be locked in position if desired. To release it, press the small button that is exposed when the lever is activated.

Exposure Control

Shutter Priority Mode
The AE-1 Program offers a variety of exposure mode options. First, like the AE-1, it may be used in Shutter Priority mode. The shutter speed is selected by turning the Control Dial on the right top of the camera. If the lens is set properly to the automatic position on the aperture ring, the camera will then pick the correct lens opening to match the shutter speed selected. The camera-selected

aperture is visible inside the viewfinder in a bright numeric LED display under the image area.

Program Mode

The camera also operates in Program mode. To access this mode, make sure the lens aperture ring is set to the automatic position, and the camera's shutter speed dial is set to PROGRAM. The camera will select both aperture and shutter speed from a programmed selection which will be right for most picture-taking situations.

Manual Mode

The AE-1P also features Manual mode in which the photographer selects both shutter speed and aperture. Manual is accessed by selecting a desired shutter speed, and unlocking and turning the lens aperture ring from the automatic position to manually select the desired aperture. The meter may be used by noting the aperture indicated in the viewfinder and manually setting it, or by pre-selecting an aperture, setting it on the lens, then rotating the shutter speeds on the shutter speed dial until the pre-selected aperture is displayed in the viewfinder. The M designation at he top of the viewfinder's aperture scale will light to indicate that the lens is set to the manual position.

Flash Photography with the AE-1P

In normal operation the light metering system of the AE-1P measures light that enters the camera through the lens and is reflected from the reflex mirror to the focusing screen. However, when using a dedicated flash unit, the flash unit does the metering rather than the camera. Light striking the subject from the flash is reflected back to a sensor coupled to the flash unit's electronic system. The sensor shuts off the flash tube when sufficient light has reached the subject.

The Hot Shoe

The Canon AE-1 Program's hot shoe has a central contact and two additional contacts that link directly to electronic flash units made for use with the A-series cameras.

Dedicated Flash Photography

Canon Speedlight A-, G- or T-series flash units are dedicated, which means that when attached to the camera they automatically set certain functions. These particular flash units produce fully automatic exposure, determined by a sensor on the flash unit, when used with the AE-1P and FD lenses, assuming of course that the FD lens is set for automatic aperture selection. Whenever the flash is mounted and is ready for operation, it will automatically set the synchronization speed on the camera to 1/60 second, which is the fastest shutter speed at which the camera can be used with flash. Light metering is accomplished by the sensor of the electronic flash system. All T-series flash units may be used in Shutter Priority automatic mode but not Program because they *do not* set the synchronization speed automatically.

Other manufacturers such as Vivitar® and Sunpak® made flash units that were dedicated for use with the Canon AE-1P; these are operated in the same manner as described above. Many of these flash units can be found on the used equipment market; your camera dealer can advise you if a flash unit is suitable for use on the AE-1P.

Non-Dedicated Flash Units

Flash units that are not dedicated for use with A-series cameras can be used with the AE-1P. With these, the camera must be manually set to a shutter speed of 1/60 second or slower and the aperture adjusted manually. Follow the manufacturer's instructions for the flash unit to achieve correct exposures with the Canon AE-1P.

Flash Bulbs

Although rarely used today, flash bulbs will work with Canon AE-1P cameras. If you are using type FP, MF or M flash bulbs, 1/30 second is the fastest shutter speed you can use. Naturally, with flash bulbs there is no automatic flash operation.

Additional Features

The "B" Setting

When the shutter is set to the "B" position in Manual mode, the shutter will remain open as long as pressure is maintained on the

shutter release button. Naturally, the camera's light metering system will not operate when the camera is set at "B" position.

Self-Timer

The self-timer on the AE-1 Program is activated by a small lever mounted on the hub of the film advance lever. This lever has three positions moving clockwise from the "A" position that indicates normal camera operation. If you move it clockwise to the "L" position, the camera is locked and will not fire. Clockwise from this position is one marked with the letter "S." This sets the camera's self-timer for a ten second delay. The self-timer is activated by pressing the shutter release button in the normal way. The camera issues an audible beep to signal the self-timer is operating. This speeds up as the camera is about to fire. The self-timer may be cancelled by moving the lever to the "L" position anytime during the countdown.

The Canon AE-1 Program features open aperture metering. It is only when the picture is made that the lens closes down to the aperture recommended by the camera's light meter. However, an FD lens set for manual operation can be stopped down to its taking aperture using the depth of field preview. By using this lever, located to the lower left of the lens mount when the camera is held in shooting position, a photographer can judge which portions of the scene will be rendered in sharp focus.

Depth of Field Preview
The depth of field preview makes it possible to see what areas will be sharp and unsharp by stopping down the lens' aperture to the actual taking position. The depth of field preview lever is found on the left side of the camera's lens mount and must be pushed in toward the lens for operation. It only operates when the lens is set for manual aperture setting and is also used for stopped-down metering. See page 61.

Film Plane Indicator
A small circle with a line through it on the right of the rewind knob shows the exact position of the film plane inside the camera. This is useful in certain types of macro and photomicrography when the distance from the film to the subject must be calculated with precision.

Canon Accessories
The AE-1P can be used with Winder A and A2, and the Motor Drive MA, for fast action pictures, and also with Data Back A, which allows the date to be printed on the pictures during exposure. Eyesight correction lenses (diopters) are also available for the viewfinder eyepiece.

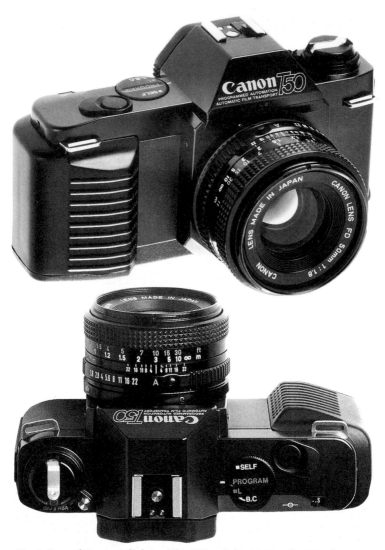

(Top) One of Canon's lightweight SLRs of the 1980s, the T50 features Program mode and a built-in winder that automatically advances the film after each exposure. (Bottom) Controls located on the top of the T50 are (left to right) the film rewind assembly surrounded by the ISO/ASA dial, hot shoe with dedicated contacts, electronic input dial, the shutter release button, and frame counter.

Canon T50

By 1982 autofocus was well-established but only readily available in compact cameras. The first AF SLR cameras, like the Pentax MEF and the Olympus OM30, were just beginning to appear. The Nikon F3 with autofocus head was on the market, too; but the Nikon FM2, with a shutter speed of 1/4000 second was better accepted. Minolta was pinning its hopes on the X700, with TTL flash metering.

Realizing that a new generation of Single Lens Reflex cameras was necessary in the very competitive market of 1982-1983, Canon developed the T50, their first camera with a winder integral to the camera body. In addition to the built-in winder, the T50 was distinguished for its advanced flash automation and its very lightweight polycarbonate body, all of which appeared for the first time in a Canon product.

Basic Camera Operation

The camera has an electronic input dial on the top right which acts as "command central." This should be left in the "L" (for lock)

The camera's electronic input dial is simple and straightforward. "L" locks the shutter release, "B.C." is the battery check, PROGRAM is the camera's only exposure mode, and "Self" activates the self-timer.

position during non-use to prevent accidental exposures. The other two positions are marked as "Program," for normal picture-taking, and "Self," the self-timer position, for delayed operation. In this mode the picture is taken ten seconds after the shutter release is pressed.

Installing the Battery

If you open the battery compartment on the right underside of the T50 camera and load two 1.5 volt AA-size cells, this provides power for all the camera's operations. You can use alkaline-manganese or zinc-carbon batteries; but zinc-carbon batteries provide relatively poor performance. Rechargeable AA NiCd cells are not recommended in the Canon T50. To check battery operation on the T50 camera, turn the electronic input dial to the BC (Battery Check) setting. When the dial is in this position, if the batteries have sufficient power, the camera will emit a beeping tone.

Do not test the batteries very often! Each test of the battery uses considerable battery power to operate the audible signal. Each time the battery gives a good test, you have plenty of power for several rolls of film, so frequent testing of the batteries is not essential.

Loading the Film

Open the camera back by pulling upwards on the film rewind knob. Load the film cassette into the film cassette chamber on the left side of the camera and pull the leader of the film across until it lines up with the film advance spool and the red mark on the camera body. Once you have placed the film in this position, be sure the cassette is flat and fully inserted and then close the camera back. The camera will automatically wind the film to the first frame. While automatic film loading operation normally has few problems, its always a good idea to watch the film rewind crank during the automatic advance cycle to make sure that it turns, indicating that the film is actually being pulled through the camera.

Film Transport

The film is automatically advanced by the built-in motor winder. Each time a picture is taken, the film is transported to the next frame. It is also possible to take a series of pictures by holding the

On the top of the camera to the left of the prism is the camera back release, film rewind crank and film speed dial. Film speed is set by pressing the chrome button and turning the ISO speed scale.

shutter speed button in the depressed position. This allows pictures to be taken at a rate of two frames per second. The frame number can be seen in the small window just behind the shutter release button.

Rewinding the Film
When you have reached the end of the film, the camera will emit a beeping tone. At this point, press the film rewind release button on the bottom of the camera, unfold the crank on the film rewind knob, and turn it in the direction marked until you feel the release of tension indicating that all the film has gone back into the cassette. Once you are absolutely certain that all of the film is in the cassette, you can pop open the back and remove the film cassette for processing.

Setting the Film Speed
The film-speed dial is located underneath the film rewind knob on the left top of the camera. Pressing the chrome button located to the right of the ISO/ASA scale releases the dial and allows you to turn it to the appropriate setting. Film speeds are available from ISO 25 to ISO 1600.

The Viewfinder

The view through the viewfinder of the T50 is clear and sharp because you are looking at a fine grain focusing screen with focus assists in the center. In the middle of the focusing screen, you will

Clear and to the point, the T50's viewfinder is easy to understand. On the right, a steady "P" indicates the use of Program mode with adequate light for handheld photography. The lightning-bolt symbol confirms that the flash is fully charged, and "M" is a warning that the lens is not in the automatic position.

see a microprism ring with a split image rangefinder in the center. Either or both of these may be used to assist in focusing, or you can focus on the surrounding area of the screen. To the right of the focusing screen are three indicators, "P," a lightning bolt, and "M." The "P" lights when Program autoexposure is set between the speed of 1/1000 and 1/30 second. At speeds below 1/30, the "P" blinks slowly to indicate that the shutter speed is too slow for hand-holding. When a dedicated flash unit is mounted on the camera, the lightning bolt symbol will light to indicate that the flash is ready for operation. If the "P" blinks very quickly after an exposure, this is an indication that the flash did not provide sufficient light to properly expose the subject. The "M" lights when the aperture ring on the FD type lens is taken off the automatic position and an f/stop is set manually. In the "M" position, the camera provides only a single 1/60 second shutter speed.

Lens Compatibility

Light measuring in the T50 is accomplished by an open-aperture metering system which works with FD mount lenses. When mounting an FD lens to the Canon T50, the lens diaphragm ring must be set to the automatic position. Because they lack the proper coupling lever, older FL lenses cannot be used with the Canon T50 and will not provide correct exposure.

The Light Meter

The light meter of the T50 is an integrated, center-weighted type, which places most of the emphasis on the central part of the frame. The measuring range of the Canon T50 is EV 1 to EV 18.

Difficult Metering Situations
The camera's center-weighted metering system and the Program control produces good pictures in most lighting situations. However, under certain circumstances, the light metering system of the T50 will not provide the best exposure. In such cases, the T50 offers ways of solving the problem: it is easy to set the film dial to an ISO speed other than the rated speed of the film. If you set the dial to a higher speed than the actual speed of the film, this is equivalent to adding a minus correction to the exposure. If you set the ISO dial to a lower film speed than the actual speed, this is equivalent to a plus correction. Unfortunately, because the film speed dial only goes to 25 at the lower end, it is impossible to put in a plus correction with such films as Kodachrome 25 or Ektar 25. Films with ISO of 50 allow a correction of +1 stop.

Substitute Subject Metering
With subjects of unusual reflectance or in contrasty lighting it is possible to take a light meter reading from something other than the subject you are planning to photograph. You can use a KODAK® Gray Card, the palm of your hand, green grass or any other subject that provides a good medium tone for proper metering. To do this, point the camera at the medium-toned subject, set the electronic input dial to the self-timer position and depress the shutter release button. In the ten second period that elapses

The Canon T50's automatic Program mode makes it a perfect camera for snapshots such as this portrait of the family cat.

between the time you pressed the button and the time the camera actually takes the picture, you can recompose the picture as you desire. The camera will hold the exposure selected at the time the shutter release button was pressed.

Exposure Control

Aperture and Shutter Speed Control

The aperture in the lens is normally controlled from the camera. The lens' manual aperture setting ring is not used with the T50. The T50 has an electronically controlled, metal-bladed shutter that provides shutter speeds from 2 seconds to 1/1000 second.

Program Mode

The only mode offered by the Canon T50 is Program autoexposure. No other modes are available on this camera except for the flash mode, which sets the camera automatically to the 1/60 sec-

Because the photographer wanted to retain detail in the rocks in the fore-ground, a plus correction was made by halving the ISO setting. This compensated for the bright, foggy background.

ond flash sync speed when used with a dedicated Canon Speed-light. In Program mode, most types of pictures can be taken successfully provided you're using an FD-mount lens. The lens' aperture ring must be set to the automatic position, marked with a green "A" or a green zero "0." The camera shutter operates between 1/1000 second and 2 seconds and the Program mode will select the proper shutter speed and the recommended lens aperture for proper exposure based on the film speed in use.

When the control knob on top of the camera is set to the program mode, a "P" will be visible to the right of the focusing screen inside the viewfinder. At shutter speeds between 1/1000 and 1/30 second, this "P" is continuously lit. When the light metering system chooses a shutter speed slower than 1/30 second, the "P" flashes, as a warning that the shutter speed is too slow for hand-holding. If

this happens, you can still take a picture, but you must support the camera on a solid surface or on a tripod. If the "P" blinks very rapidly, this indicates the flash that is mounted cannot provide sufficient light.

Flash Photography with the T50

The T50 is fitted with a standard hot-shoe with a central contact and two additional contacts for use with Canon dedicated flash units. Flashes in the Speedlight series with flash automatic or program automatic from Canon may be used with the T50. When fitted with a Canon dedicated flash, the camera will automatically make all settings required for good results.

Additional Features

Self-Timer
For time-delay pictures, the self-timer provides a pause of approximately ten seconds. To activate the self-timer, set the electronic input dial to "Self" and press the shutter release button. The light metering information is memorized at the moment the shutter release button is depressed and held. This allows you to also use the self-timer as an alternate means of corrective metering (Also see the section *Substitute Subject Metering.*)

Electronic Cable Release
A T50 camera does not have a fitting for a standard cable release. Instead, the camera will accept an electronic cable release. There is a socket on the camera into which the Canon electronic release is screwed. The button on the cable release then fires the camera shutter and can be used in the normal mode or in the self-timer mode.

Canon Accessories
Flashes in the Speedlight series with flash automatic or program automatic from Canon may be used with the T50. Also eyesight correction lenses can be fitted onto the T50 eyepiece.

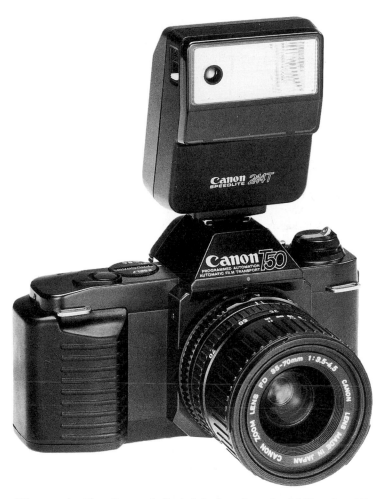

When used with a Canon dedicated flash such as the 244T and an FD lens, the T50 will automatically choose settings for good results.

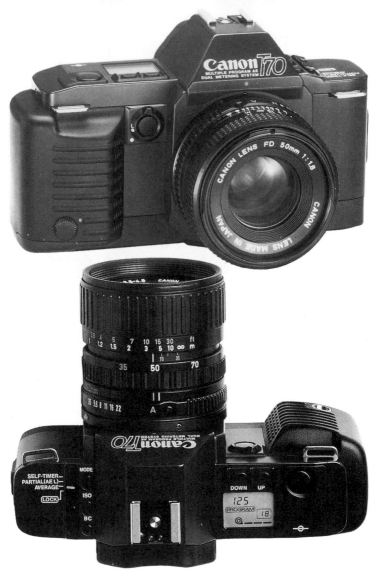

(Top) Canon's first multiple mode SLR with built-in film advance, the T70 became a very popular part of the Canon line-up following its 1984 introduction. (Bottom) The top of the T70 features (left to right) the main control switch; mode, ISO and battery check buttons; hot shoe with dedicated contacts; LED panel with UP/DOWN buttons; and the shutter release.

Canon T70

The Nikon FA, the first camera with multiple field (so-called matrix) light metering was now on the market. This would turn out to be a trend-setting innovation. Minolta's X-series continued with the X500 and the X370 (X300 in some markets). Also, Leica introduced the R4S and the R4 with features designed for professional as well as amateur photographers.

The Canon T70 attracted its share of this market with a very good price and desirable features, continuing the design philosophy first developed in the T50. The T70 has a built-in film advance motor as does the T50. However, where the T50 was a basic camera with only one mode of operation, the T70 is a much more advanced camera with multiple modes. The T70 is also the first Canon camera to feature an LCD panel on the top of the camera displaying all camera operations.

Caution: If you are planning to buy a "used" Canon T70, be very careful to check that the LCD panel still operates. These LCDs have a limited life span and often on a T70 camera, the LCD panel has simply ceased to function and gone dark. The LCD panels on most cameras have lasted an average of five years although in many cases they do last longer than that. It is also normal for the LCD to be inoperable at very low temperatures and to go dark at very high temperatures. Both of these effects are temporary; the LCD will return to normal operation when the camera is returned to normal temperature.

Basic Camera Operation

The Main Control Switch
On the left top plate of the camera is a switch that can be set to any of four positions. When the camera is not in use the switch should be left in the lock position, which shuts off power to the camera and prevents accidental exposure. The two positions most commonly used for general picture taking sit just above the lock

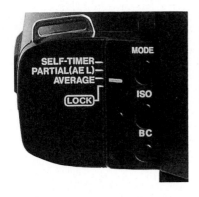

Controls on the left side of the camera include the main control switch, which turns the power on and sets the metering mode and the self-timer. The buttons next to this switch set the exposure mode, ISO film speed and check the battery power.

position. The first, marked "Average," sets the camera for a center-weighted averaging metering pattern, while the second position, marked "Partial," sets the camera for a semi-spot metering pattern with autoexposure lock capability. The fourth position at the top is a self-timer position for a delayed shutter release.

Installing the Batteries

Open the battery compartment on the right underside of the T70 and load with 1.5 volt AA batteries. Alkaline-manganese batteries are recommended for best performance. It is also possible to use NiCd rechargeable cells in the T70 but they will not provide power for very long operation. To test the batteries once they are loaded, press the button marked "BC on the upper left top deck of the camera just next to the prism hump. When you press this button you should see three straight lines on the LCD panel next to the picture of the film cassette. Three straight lines indicate batteries at optimum performance. If only two straight lines appear, then the batteries are good but are getting weaker and if only one straight line appears, the batteries should be replaced soon. If one straight line appears and blinks, the batteries *must* be replaced immediately. It is not necessary to test the batteries very often. Test them when they are first loaded and after every few rolls of film and you should be in good shape.

◁ **The lightweight, easy-to-use T70 is an ideal camera for traveling. Using Program autoexposure mode with full-area metering insures accurate exposures in most situations.**

The deep sky, white clouds, and striking contrast in the rocks are examples of how an image can be enhanced by the use of a Polarizing filter.
Photo: Bob Shell

Loading the Film

Open the camera back by sliding the indented opening catch. Load a 35mm film cassette into the film chamber on the left hand side of the camera and make sure that the film leader comes to the red film mark on the right side of the camera. If the leader does not extend far enough, pull it out slightly to make sure that it comes to the mark. Once you've got the film in place, check to make sure that the film cassette is fully inserted into the chamber and lying flat, then close the camera back. The film will automatically be transported to the first frame.

Once you have loaded the film and the film has advanced to the first frame, look at the LCD panel. There is a small image there of the film cassette and next to that three straight lines representing the film extending from the cassette. If the lines and the cassette appear, there is no problem with the film loading. If the lines

flash, then the film is not loaded properly and must be reloaded. Should this happen, open the back of the camera, check that the film is pulled fully to the red film start mark and close the back again.

Caution: While loading the film, be extremely careful not to touch the camera shutter with your fingers. The shutter is a very delicate mechanism and easily damaged.

Film Transport
The film transport operates automatically each time a photograph is taken. The frame number of the film is displayed on the LCD panel.

Rewinding the Film
When the film has reached its end, the camera emits a beeping sound. When this happens you must press the film rewind button on the bottom right side of the camera and then press the film rewind activating button. The camera will rewind the film via the camera's motor system. You may verify that the camera is actually winding the film backwards because the frame counter on the LCD panel will count down backwards, as well.

Setting the Film Speed
Once the film has been loaded into the camera, press the ISO button on the left side of the camera's top plate near the prism hump. Then use the Up and Down buttons on the top right side to change the ISO, which is displayed on the LCD panel. The range is from ISO 12 to ISO 1600 in 1/3 stop increments.

The Viewfinder

The viewfinder of the Canon T70 is bright and clear and displays a lot of useful information. In the center of the focusing screen is a new type of split-image rangefinder, developed by Canon. Instead of incorporating just two facets of prisms molded into the surface of the screen, Canon's innovative split-image is made up of multiple tiny wedge-shaped facets. This looks to the eye just like any other split-image rangefinder, but is less prone to darkening on

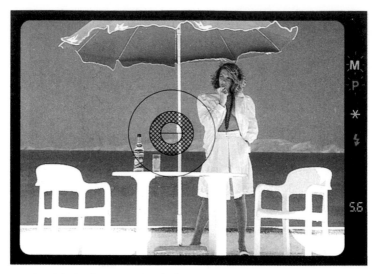

On the right in the T70's viewfinder from top to bottom: "M" indicates the camera is in Manual mode, "P" is Program mode, the asterisk signals spot metering is set and the lightning-bolt is the flash ready signal. Either the aperture or shutter speed setting is displayed at the bottom.

one side when used with lenses of lower maximum apertures, such as telephotos and zooms. Surrounding this new split-image range-finder is a traditional microprism ring, which some photographers find easier to use than a split-image rangefinder. Surrounding this is a scribed ring that shows the area covered by the partial meter-ing or spot metering option.

To the right of the focusing screen is a vertical panel that dis-plays lighted information to assist the photographer. At the top is an M, displayed when the camera is set for manual operation. Directly under this is a P, which lights up when the program mode is used. Just below this is an asterisk (*) which illuminates when the spot meter is in use. Below this is a lightning bolt symbol which lights up to advise that the flash is ready to fire when the camera is used with the correct Canon Speedlite flash units. Last of all is a two-segment alpha-numeric display showing the lens aperture selected in some modes and the shutter speed in others, as well as showing over- and underexposure warnings.

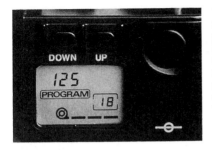

This LCD panel indicates that the camera is in Program mode, a 1/125 second shutter speed has been selected by the camera, and the film is on the 18th frame. The UP and DOWN keys above the panel are used to scroll through various camera functions.

The LCD Panel

On top of the camera just to the right of the prism hump is the large LCD panel that displays operational mode, shutter speed, aperture, film loading confirmation, battery test, self-timer countdown, frame number, etc.

The Light Meter

With the T70, you have two separate metering patterns, spot-metering and full area metering, at your disposal. One or the other will be usable for almost all picture taking circumstances.

Metering Range
The measuring range of the light meter, when the camera is loaded with 100 speed film and fitted with an f/1.4 lens is EV 1 to EV 19.

Using full-area or average metering measures exposure for the entire area of the scene in the viewfinder. More emphasis is placed on the center area. Partial spot metering measures only a small area in the center of the viewfinder and is useful in difficult lighting situations.

This corresponds to a range from 1 second at f/1.4 up to 1/1000 second at f/22.

Full Area Metering

When set in the "Average" position, the camera measures the entire image area in the focusing screen. Nevertheless, it puts more of the emphasis on the center area than on the surrounding area. This is often referred to as a center-weighted metering pattern and is perfect for most types of picture taking.

Partial Spot Metering

To use the spot metering option, set the main control to the partial metering position. When set this way, the light meter measures only the portion of the image inside the central area of the focusing screen, which is marked on the screen with a circle. Spot metering is helpful in difficult lighting situations because, partial pressure on the shutter release button memorizes and holds a metering reading and the picture may be recomposed without altering the reading. When set for the spot metering mode a red asterisk appears inside the viewfinder as an indication that the spot metering mode is active.

Open Aperture Metering

Open aperture metering is the normal type of metering in the Canon T70: the camera takes its light readings with the lens fully open and extrapolates for other apertures. This metering only operates with FD-mount lenses.

Stopped-Down Metering

It is also possible on the T70 to use stopped-down metering, which means that the lens is set to the working aperture at the time the meter reading is taken. This method should be used with Canon FL lenses or mirror lenses. Mount the lens on the camera as usual and stop the FL lenses down manually using the manual aperture control ring. See also, *Stopped-down Aperture Priority Mode,* page 89.

Get in close for a more interesting composition and to show off detail. **The striking label on this weathered seed box was worth bending down to photograph. Photo: Bob Shell**

Because the apples are of medium tonal range, a correct exposure was made using average metering and Program exposure mode.

Exposure Control

Aperture and Shutter Speed Control
The aperture mechanism on the T70 is designed to work automatically with FD mount lenses. The aperture may be stopped down manually on those lenses that have an aperture stop-down ring. The metal-bladed shutter is electronically timed and operates vertically. It offers shutter speeds from 2 seconds to 1/1000 second.

Program Options
In addition to the standard Program mode on the T70, there are also two other automatic programs for use with particular types of lenses. These are designed either to give the maximum depth of field when using wide-angle lenses, or to provide a fast shutter speed to compensate for camera shake when using long lenses.

The first program is called "Wide Angle Program" while the second is called "Tele Program."

Using the Program Modes
By using the three different program modes of the T70, you can match the camera's performance to any FD-mount lens. When using FD-mount lenses with the program options on this camera, you must set the aperture rings on the FD lens to the automatic position indicated by a green "A" or a green "0." To set the desired program mode on the camera, press the Mode button on the left top plate and use the Up and Down buttons on the top right side in front of the LCD panel to get the correct indication on the panel.

The electronically timed shutter on the T70 will provide shutter speeds from 1/1000 second to 2 seconds. The programmed automation will choose the best possible shutter speed to match the aperture opening based on the amount of light available. The standard program mode will regulate the shutter speed from 1 second to 1/1000 second and the aperture to 1.4 based on the lens in use and the amount of light available. However, the wide program favors smaller apertures and will time only to 1/2 second, while the telephoto program tends to favor a larger aperture and a faster shutter speed. Something in the neighborhood of 1/300 second is preferable to eliminate possible camera shake.

Warning signals: In all three program modes, the P indicator in the viewfinder will act as a signal to help you prevent camera shake. If the P begins to blink slowly, this indicates that the shutter speed will be too slow for hand-holding. In the Tele Program mode, this indication begins at 1/125 second; in the standard Program mode it begins at 1/60 second; and in the Wide Program at 1/30 second. You can still take pictures at speeds slower than these but the warning is to let you know that you must brace the camera on a solid surface or use a tripod.

If the smallest aperture of the lens blinks rapidly in the viewfinder, this indicates overexposure. At the same time the 1/1000 second indicator in the LCD panel will blink slowly. If the illuminated "P" in the viewfinder blinks slowly and the largest aperture of the lens blinks quickly, this is an indication of underexposure. At the same time, the longest shutter speed in the LCD panel, will blink slowly.

Shutter Priority Mode

With Shutter Priority mode, the photographer sets the desired shutter speed and the camera selects the proper aperture for correct exposure. Shutter Priority will only function with FD mount lenses because these lenses have the proper coupling to allow the camera to automatically select the aperture opening. For this mode to operate, the aperture ring of these lens must be set to the automatic position which is indicated by a green "A" or "O."

To choose Shutter Priority, press the Mode control button on the left top plate and use the Up or Down buttons on the right hand top plate of the camera to cycle through the modes until Tv (Time value) is displayed on the LCD panel. Once you have set the camera for the Tv position, you may use the Up and Down buttons to cycle through the shutter speeds from 1/1000 to 2 seconds. Once you have selected the shutter speed the camera will then select the proper aperture and indicate this aperture in the viewfinder. With a film of ISO 25 or 50, all shutter speeds will be available. However, as you increase the speed of the film you will find that the slowest shutter speed available will change so that when you load a 100 speed film the shutter speed range available to you is from 1/1000 second down to 1 second and with a film of ISO 3200 you will find that the slowest shutter speed available is 1/30 second. The LCD panel displays the selected shutter speed in shorthand form, showing 125 when 1/125 second is selected and so on throughout the speed range. For over- and underexposure warnings, the smallest or the largest lens aperture indication in the viewfinder will blink rapidly. When this happens you must select a different shutter speed until the aperture indicator no longer blinks.

Aperture Priority Mode

Aperture priority works similarly to Shutter Priority mode, except the photographer selects the desired lens aperture and the camera will automatically select the correct shutter speed for proper exposure. To set the camera for Aperture Priority autoexposure, press the Mode control button on the camera's top left and use the Up or Down buttons on the right to cycle through the modes on the LCD panel until Av is displayed.

Because the T70 uses an electronically-timed stepless EMAS (ElectroMagnetic Attraction Shutter) module, shutter speeds in

Aperture Priority mode are not limited to full-stop speeds typically found on shutter speed dials, such as 1/30, 1/60, 1/125, etc. Instead, the camera can set the precise shutter speed to produce the proper exposure. Thus, it is possible for the T70 to deliver a shutter speed of 1/350 second if that is required for the correct exposure at the selected aperture.

In this mode, you are also warned of over- and underexposure by blinking displays inside the viewfinder.

Stopped-Down Aperture Priority Mode
Occasionally a photographer will want to use lenses or accessories that lack the coupling pins to convey diaphragm settings to the camera body. These include the Canon Mirror lens 500mm f/8, the 7.5mm f/5.6 Fisheye lens, any FL lens, or accessories like certain extension tubes, bellows, microscope attachments, telescope attachments, and slide copiers.

If the camera is set for Aperture Priority mode and an uncoupled accessory is attached, the camera may be cycled through its modes until the Av indicator on the LCD panel disappears and is replaced by a circular symbol of a lens diaphragm. You should frame and focus your image prior to doing this, because when this mode is selected, the lens' aperture is closed down to allow metering at the actual taking aperture. If you then slightly depress the shutter release button, the shutter speed selected to match the stopped down or working aperture will be displayed in the viewfinder. Because the two-digit display normally used for apertures is used here to indicate shutter speeds, it will not display any speed faster than 1/90 second. Faster speeds are indicated in a sort of shorthand code, with "HL" indicating anything from 1/125 up to 1/350 and "HH" indicating anything from 1/500 to 1/1000. If you want to know the precise speed selected, you must look at the LCD Panel on top of the camera, where it will be displayed to the nearest half stop. Overexposure is indicated by a blinking "HH" symbol in the viewfinder and a blinking 1000 in the LCD panel. A 2 will flash both in the viewfinder and on the external LCD if the image will be underexposed.

Manual Mode
Manual exposure metering with the T70 is not particularly convenient. To access the full Manual mode you must set the camera

to the Tv mode, which allows you to select the desired shutter speeds. Then take the lens off of its automatic setting and manually select the lens aperture. The camera will indicate the aperture that it would have selected both in the viewfinder and on the LCD panel, and you can use that as a reference to manually set the lens, or change the shutter speed to produce a different aperture selection.

Under- and overexposure warnings are displayed as above and you may heed or ignore them depending on the type of image you desire.

Exposure Compensation

The Canon T70 does not offer an exposure compensation setting *per se*. Because it is a fully automatic camera, designers figured that most purchasers would not need or use such a feature. However, compensations are possible in a couple of ways.

Substitute metering: You may easily take a meter reading of a substitute subject with the T70 in Av or stopped-down mode by using the shutter speed locking ring on the front of the camera. This will hold the shutter speed while the substitute meter reading is taken; then you may recompose as desired and take the photo. You may meter from a KODAK ® Gray Card, the palm of your hand, or any suitable alternate subject. By using the spot metering mode combined with a zoom lens, you may take a meter reading from a very small area.

Instead of using the shutter release button, the exposure preview button on the right front of the camera can be used to activate the meter. Surrounding it is the shutter speed locking ring, which locks exposure in Aperture Priority mode.

Alternate film speed: If you know you want to apply a set exposure factor to an entire group of photos, you may easily do so by setting an ISO different from the actual ISO speed of the film. For example, if you are using a 100 speed film and wish to add a compensation of +1 stop, you would set the ISO to 50. This produces a nominal one stop overexposure or compensation. Conversely, to achieve a -1 stop compensation, you would set the ISO to 200.

Flash Photography with the T70

The Canon T70 features a hot shoe with the standard central contact and with two supplementary contacts for dedicated operation with Canon and other compatible electronic flash units.

Dedicated Flash Photography
Full flash automation is possible with Canon A- or G-series Speedlites or flash units from other manufacturers with full A- or G-series compatibility. These dedicated flash units will provide full flash automation when used with the T70 and FD lenses with the aperture ring set in the automatic position. When the flash is ready to fire, it will automatically set the T70 shutter to the 1/90 second flash synchronization speed. Also, when the flash is ready to fire, the lightning bolt flash-ready symbol will light in the viewfinder display to the right of the image area.

If you set the aperture ring to a manually-selected aperture, causing the red "M" in the viewfinder to blink, the flash automation will still work, provided you have not selected too small an aperture.

Please note: Speedlites 177A, 188A, 533G and 577G will not automatically switch the camera to the flash sync speed of 1/90 second; you must remember to do this manually. The flash ready symbol in the viewfinder will work with these flash units, but the warnings for exceeding the automatic range will not function.

Canon Speedlite 277T: When using the Speedlight 277T observe the following points: Canon's 277T electronic flash unit uses a variation on the standard automatic flash principle. Just prior to the exposure, these flash units send out a brief flash of infrared

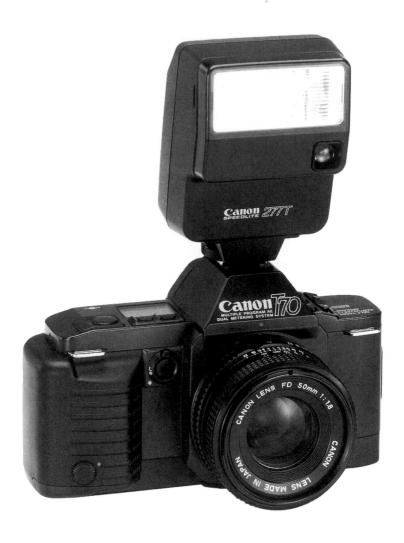

With the Canon T70, the 277T Speedlite and an FD lens fully automatic
flash exposures are possible. Set the lens to the automatic position and
the flash to PROGRAM. The flash uses an infrared preflash to determine
exposure.

light, which reflects off the subject and back to a sensor on the flash unit. This allows the flash to pre-measure the distance and reflectance characteristics of the subject before the flash actually fires. This system produces much more accurate flash exposures than was previously possible with simple sensor-type automatic flash units. When using this flash unit on the T70, make certain that the lens is set to the automatic position. The camera and flash will select the best aperture for the subject distance and reflectance characteristics of the subject, so long as the switch on the rear of the flash is set to PROGRAM.

When using what Canon calls the "variable flash mode," you select the aperture you wish to use. You do not do this on the camera, as you might expect, but instead on the rear of the Speedlite 277T. First you move the left hand switch from the PROGRAM position to the NO. SET position, at which time f/5.6 will light up. If you want a different aperture, press the button on the right to cycle through the available apertures until the one you want is illuminated. If you attempt to select an aperture that is not available on the lens in use, the aperture value in the camera viewfinder will blink. In this mode, the infrared preflash does not function.

You can use this mode to select a small aperture for extended depth of field, or you can use it to pick a large aperture so that the flash will fire at relatively low power and recycle faster.

Non-Dedicated Flash Units
Canon recommends against using other brands of flash on the T70 unless specifically made to be compatible, as they may damage the camera's electronics. Check with a knowledgeable Canon dealer before using any questionable flash unit on the camera.

Additional Features

The "B" Setting
If you set the camera for Shutter Priority (Tv) operation and scroll through the shutter speeds, you will come to the word "Bulb." As soon as you reach this setting, the Tv disappears and is replaced by M to remind you that the automatic metering does not work with the "B" setting. In this setting, the shutter will remain open as

long as pressure is maintained on the shutter release button. At the same time the LCD panel will count the time for you up to 30 seconds, so you can accurately time long exposures. After 30 seconds, the counter starts over and one of the black battery test bars appears. After a second, 30 seconds, a second bar appears and the timer re-starts. Thus, with all three bars and the counter re-starting again, you can accurately time up to 120 seconds, which ought to be long enough for most situations. For exposures longer than 2 minutes, you'll have to supply your own stopwatch.

Self-Timer

To operate the self-timer, move the main switch to the position marked SELF-TIMER. This also sets the camera for center-weighted integral metering. Once you have focused the camera, you can start the self-timer by pressing the shutter release button. The T70 beeps during the ten-second countdown, and the beeps speed up during the last two seconds. At the same time the LCD shows a countdown to the exposure. The self-timer is obviously useful for getting yourself in the picture, but is also useful for taking low vibration photos in the absence of a cable release.

Cable Release

The T70 does not accept a standard mechanical cable release, but instead accepts an electrical one that plugs into a socket on the bottom front of the handgrip. Only electrical cable releases with the special Canon fitting can be used.

Setting the camera for automatic operation allows the photographer to ⇨
concentrate completely on the subject and composition. Photo: Bob Shell

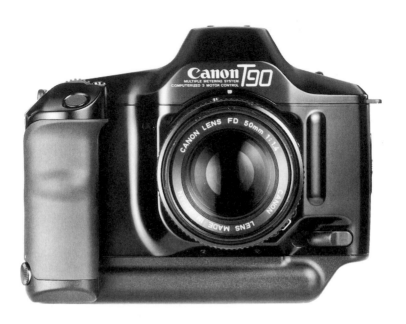

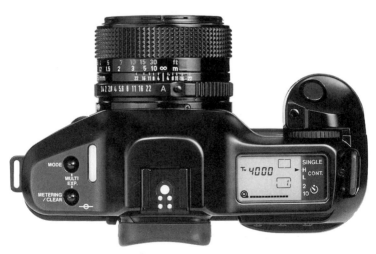

(Top) The Canon T90 was Canon's last major manual-focus SLR.
(Bottom) Controls on the top of the camera include (left to right) mode,
multi-exposure, and metering clear buttons; hot shoe with four dedicated
contacts; LCD Panel; electronic input dial; and shutter release.

96

Canon T90

By 1985 Minolta had set the pace for the worldwide photo indus-
try with the Maxxum/Dynax 7000, the most advanced autofocus
SLR camera of its time. Pentax introduced the ME-F, as well as a
complete system of lenses and flash equipment. Nikon introduced
its first camera with an integral film advance motor, the N2000
(called the F-301 in many markets). Konica introduced the TC-X,
the first SLR camera which read DX-coded ISO speeds from film
cassettes.

Into this market Canon introduced the T90, a camera with a
very futuristic design and features that made it the ultimate man-
ual-focus SLR camera of its time. Although it wasn't common
knowledge, the T90 was Canon's "testing ground" for the drive
systems, shutter and other internal mechanisms which would later
be used in the EOS system, one of the most technologically
advanced photographic systems available today.

With the Canon T90, the manual-focus 35mm SLR camera
reached its high point. You can look back to the A-1 and see just
how much Canon accomplished in eight years of active develop-
ment of SLR features and functions. Much of this can be attributed
to a genuine desire on Canon's part to produce the a camera with
the best possible performance in an ergonomically-designed body.
To develop a prototype SLR body that conformed to the user's
hands, Canon called on the famous designer Luigi Colani. The
Colani prototype was very advanced and totally futuristic. It had
to be modified considerably for actual production, both to fit the
inner mechanisms and not to cause too much "future shock" to
the potential camera buyer. However, with the T90, the future of
Canon's camera development for the next ten years was written.

Basic Camera Operation

The Main Control Switch

The main control switch is on the lower-left, back side of the cam-
era. When you are not using the camera, always slide this switch

On the lower back of the camera is the main control switch. The "L" setting locks the shutter release, and the "A" setting activates the camera. The two buttons to the left are used with the electronic input dial to set the ISO film speed and exposure compensation. If pressed together, they set the safety shift.

to the left position marked "L." This shuts off power to the camera and prevents accidental exposures. It also turns off the LCD panel and reduces battery drain during non-use. Always remember to slide this switch to the right to the "A" position before trying to operate the camera.

Installing the Batteries

The battery compartment of the T90 is located on the bottom of the camera's right side. To open it, lift and turn the key and slide the battery holder out toward the right. Load four size AA cells into the battery holder, paying particular attention to the diagram in the compartment to make certain that the batteries are inserted correctly. Then slide the battery holder back into the camera all the way and turn the locking key to latch it into place. Fold the key out of the way for security.

After loading the batteries, test them to make certain they are fresh and properly installed. Do this by opening the hinged door on the right end of the camera and pressing the battery test button. If the batteries are good you will see three black bars displayed on the LCD panel. If only two bars appear the batteries are not very fresh and you should plan on replacing them relatively soon. If only one bar appears, the batteries are quite weak and should be replaced promptly. If no bar appears, the batteries are either dead or installed incorrectly. Try removing them and re-installing them. Often wiping the contacts on each end of the batteries with a clean cotton cloth will solve the problem.

I recommend checking the batteries after every three or four rolls of film just to keep track of their status. This is important because the T90 will not function at all with dead batteries.

Loading the Film

To open the back of the T90, simultaneously press the locking button on the left end of the camera while sliding the latch just below it downward. For some people this is quite difficult and requires practice, but it becomes easy after a while. Once you have mastered this, the back will pop open easily.

After opening the back, load the film cassette into the chamber on the left side of the camera making sure that it slips in and all the way up onto the forked shaft. To do this properly, you must insert the top end first and then swing the cassette down and in. Once the cassette is properly installed in the camera, pull the film leader out until the end reaches the red mark inside the right side of the camera. Take care not to touch the camera shutter when doing this; it is very delicate. Once the film is pulled out far enough, close the camera back. The camera will then load the film automatically and advance it to the first frame. You may verify correct film loading by looking at the LCD panel. If the film is loaded properly you will see a drawing of a cassette with film protruding from it. If the protruding film is not shown and the cassette blinks, the film did not load properly. Open the camera back and load the film again, making sure the end of the film tongue is pulled far enough to the right.

Film Transport

The film transport system on the T90 is driven by a powerful built-in motor. Three different modes for film advance are offered: SINGLE, which advances the film only one frame at a time, each time the shutter release is depressed, L CONT which continuously advances the film at low speed as long as the shutter button is held down, and H CONT which works just the same but at a higher speed. L CONT will advance the film at a maximum of 2 frames per second, while H CONT advances the film at a maximum speed of 4.5 frames per second in normal operational modes. By setting the lens manually for stopped-down aperture operation it is possible to increase the speed to a full 5 frames per second. This is quite fast even by today's standards. Naturally, the film advance speed is influenced by the shutter speed in use and by the condition of the batteries.

To select a drive mode, open the hinged door on the right end of the camera and press the bottom button. By repeatedly pressing

this button you can move the pointer on the LCD panel until it comes to rest opposite the desired drive mode. In addition to selecting drive modes, this same procedure allows you to set the self-timer with either a 2-second or 10-second delay.

Rewinding the Film

When the last frame has been exposed, the T90 will automatically commence rewinding. Rewinding is fully-motorized and quite rapid, and will be verified by the sound of the motor, sequential flashing of the film indicator on the LCD panel to show it going back into the cassette and the frame counter counting backwards. Once all of the film is in the cassette the camera will stop rewinding and the film cassette on the LCD panel will flash to remind you to take the film out. Open the camera back as described in the section on film loading and remove the cassette by pulling up on the bottom and swinging it outward.

Setting the Film Speed

Normally you need not worry about setting the film speed on the T90 since almost all film these days is DX-coded and the camera automatically sets itself to the correct ISO by reading the checkerboard pattern on the loaded cassette. Film speeds from ISO 25 to ISO 5000 are automatically set by this system. However, should you use a non-DX coded film or wish to set a different ISO speed from that coded onto the cassette, you may easily do so. Press the button marked ISO on the back of the camera, and use the electronic input dial to manually input any ISO speed from ISO 6 to ISO 6400.

The Viewfinder

When you first look into the viewfinder of the T90 you will see the bright focusing screen. The standard screen supplied with the camera has a horizontally divided split-image rangefinder in the center surrounded by a microprism ring. Both will assist in focusing the camera. The split image rangefinder works best on subjects with straight lines that can be lined up in the two halves, while the microprism works well with most subjects. You can also use any area on the fine laser matte surface of the focusing screen

The viewfinder of the T90 displays a great deal of information. At the bottom of the viewfinder (from left to right) are readouts for spot metering, shutter speed, f/stop, Manual mode/lens not set to the automatic position, flash ready, and exposure compensation. The exposure metering scale at the right is activated in the Spot and Multi-Spot metering modes.

to focus. Also marked on the screen is a reference ring showing the area measured by the partial metering setting, while the microprism ring shows the area covered by the spot meter.

Viewfinder information: Underneath the image area is a panel that displays a variety of useful information. The information shown in the viewfinder allows you to control of a number of features without the need to take the camera from your eye. You can view the exposure settings and exposure compensation on this scale, as well as identify errors. The following information is shown in the viewfinder:

❏ Spot metering active — (*)
❏ Shutter speed — four digits, blinks to warn of incorrect exposure
❏ Aperture — two digits, blinks to warn of incorrect exposure
❏ Aperture ring on lens not on automatic position — M

In preparing to shoot this picture, Bob Shell selected Aperture Priority (AV) mode and a small aperture opening. By using the stop-down lever, he confirmed that depth of field was adequate to produce sharp focus throughout the scene. The camera automatically adjusted the shutter speed for the correct exposure.

❏ Flash ready — lightning bolt symbol
❏ Exposure compensation engaged — (+ or -)
❏ Warning of metering function failure or failure of other functions (EEEE EE) — If this warning is displayed when the shutter release button is pressed, it indicates that an exposure error is occurring. This can result from the subject brightness exceeding the metering range of the camera or falling below the lower limit of that range. It may also indicate that the FD lens which is mounted on the camera is not set to the automatic position on the aperture ring.

The brightness of the LED indicators in the viewfinder is automatically adjusted based on the brightness of the ambient light, for comfort and ease of viewing. If you wish to manually adjust the brightness of the viewfinder LED displays, open the door on the right-hand end of the camera and you will see a small rotary switch with three positions. For use in bright sunlight, set this to the icon

of a sun. For more dimly illuminated conditions, set it to the middle position indicated by a round dot. If you wish to shut off the LED display entirely, set this switch to the position indicated by a circle.

The LCD Panel

The LCD panel on the top right of the camera displays the status of many of the camera functions. It shows: battery condition, exposure compensation, metering mode, exposure mode, shutter speed, aperture, film frame, film loading condition, film advance and rewind, time exposure, safety shift, and self-timer.

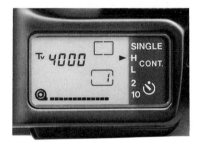

The LCD panel at the right shows the T90 set for Shutter Priority mode (Tv), 1/4000 second, and high-speed continuous film advance. The film is properly loaded and it is on frame one.

Lens Compatibility

Canon FL lenses and mirror reflex lenses: Because these lenses do not have the couplings necessary to provide the T90 camera with information about the lens opening, aperture must be set manually and metering must be done in the stopped-down mode. See also, page 110.

Canon FD and FDn lenses: Both the original FD lenses with the chrome mounting ring and the later FDn lenses with the black mounting ring work properly on the T90. The only difference between the two is that the older FD lenses fit onto the camera, then the chrome ring is turned to lock the lens in place; for the later lenses, with the black ring at the rear, the lens is pushed straight onto the camera and the entire lens is turned to lock it in place. The older FD lenses with the chrome ring are removed from

the camera by simply turning the chrome ring counter clockwise and lifting the lens away from the camera. The newer FDn lenses, which are all black, are removed from the camera by pressing the chrome release button on the lens, turning the entire lens counter clockwise and then removing the lens from the camera. Both types of FD lenses will couple with the light metering systems of the T90 and can be used in the automatic modes by setting the aperture ring on the lens to the "A" or "O" position.

The Light Meter

Metering Range

The metering range of the T90 is from EV 0 to EV 20. With a film of ISO 100 and a lens with a maximum aperture of f/1.4, this corresponds to a range from 2 seconds at f/1.4 up to 1/4000 second at f/16.

Metering Modes

The T90 offers four different light metering options for maximum versatility. The first is center-weighted averaging, the second is a more selective partial spot metering, the third is a highly selective spot metering, and the fourth is multi-spot metering. This is a feature that Canon has only offered in the T90.

To switch from one metering option to another, first depress the metering button on the top left of the camera and then turn the electronic input dial to change from one metering style to another. The metering mode you have selected appears in a small rectangle on the LCD panel above the frame counter. When this rectangle is blank, the camera is set for center-weighted averaging. When two semi-circles are displayed, the camera is set for partial metering. When only a dot is displayed in the center, the camera is set for spot metering.

The T90's large silicon meter cell is located inside the camera just above the viewfinder eyepiece. This cell reads light from the camera's focusing screen. Because the cell can also be affected by extraneous light coming in through the camera's eyepiece, the T90 has a built-in eyepiece blind. Always be sure to close this if you do not have your eye close to the eyepiece, such as when using the self-timer.

Spot metering was used for accurate exposure of this ultra-wide-angle portrait of a bride and groom. A highlight reading was taken of the white clothes in addition to a spot reading of one of the subject's face. Photo: Scott Augustine, Mayfair Studios.

Metering Mode Selection

The METERING/CLEAR button on the left top deck of the camera, used with the electronic input dial, allows you to select either full area center-weighted averaging metering, selective metering or spot metering. When set by this method, all photos in a motorized sequence will be taken at the exposure selected for the first photo.

Center-Weighted Average Metering

The silicon cell above the eyepiece is segmented so that all or part of it can be turned on or off. When the entire cell is active, the entire area in the viewfinder is measured, but emphasis is placed on the central area where important subjects are most likely to be. This metering mode is good for general photography and quick action photos, particularly with black-and-white and color negative films which require less precise exposure.

Partial Spot Metering

This mode is indicated by two semi-circles in the metering mode rectangle on the LCD panel. In partial spot metering, the central segment of the silicon cell is the only active metering area. The focusing screens for the T90 all have a scribed reference circle showing the 13% of the image area for which the meter calculates exposure.

On top of the camera within easy reach of the photographer's right index finger are the shutter release button, spot metering button and electronic input dial.

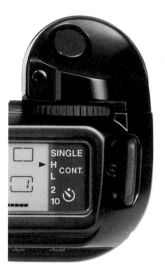

Spot Metering

In this mode emphasis is placed on the tightly defined central area represented by the 5 mm central circle on the T90's focusing screen. This corresponds to 2.5% of the entire image. The spot metering mode is signaled by a dot in the metering mode rectangle on the LCD panel and an asterisk (*) inside the camera's viewfinder.

A very small silicon cell in the base of the camera's mirror box is used for spot metering, not the larger silicon cell described earlier. Light passes through a semi-silvered central area on the reflex mirror to a secondary mirror hinged onto its back which reflects it to the small cell below. Because the semi-silvered mirror surface polarizes the light passing through it, you should not

use a standard linear polarizing filter on the T90. Only special circular polarizing filters will allow you to take proper meter readings with the T90's spot meter.

The small, black spot metering button is located on the top of the T90 handgrip, between the shutter release button and electronic input dial. Pressing this holds the meter reading for 30 seconds. This allows you to easily take a spot meter reading and then recompose the photograph without worrying about maintaining constant pressure on the shutter release button.

When you use the spot meter, a vertical scale with a triangular mark pointing to the center appears on the right side of the viewfinder. After taking a spot reading, a silver arrow appears on the scale. If you now point the camera so that a different tone is in the spot metering area of the focusing screen, you will see a second silver arrow which corresponds to the meter reading on this new subject. If it is above the first silver arrow, the new subject is brighter than the original one, and, conversely, if it is below the first arrow the new subject is darker. By noting the steps on the scale, you can determine how much brighter or darker the new area is, and, if you know the latitude of the film you are using, determine if the tonal range of your scene is within the range of the film.

Multi-Spot Metering

Carrying spot metering one step further, the T90 allows you to average three spot readings for precise exposure calculation. If you depress the spot metering button after pointing the spot metering area of the camera at a different subject, then you have taken two spot readings. The two arrows will move to a different part of the scale and the camera will indicate a new shutter speed or aperture (or both, in Program modes). The camera has automatically averaged the two readings and determined an exposure accordingly.

If you now point the spot metering circle at a different area and press the spot metering button again, a third arrow will appear and again the camera will average all three readings and provide a new exposure based on this. The proper sequence is to meter a mid-tone first, a darker tone second and a lighter tone third.

On the back of the camera within easy reach of the photographer's thumb are the highlight and shadow control keys marked with up and down arrows. The larger button to the right is the exposure preview button, which activates the camera's meter and displays.

Highlight and Shadow Control

The light metering system of the Canon T90 is the most sophisticated metering system that Canon designed for any of their cameras. It is far more complex than any metering system which went before it, and it offers capabilities not found in any Canon camera since. Perhaps some photographers find it too complicated In actual fact, there is nothing that should be confusing or intimidating about the metering system of the T90, but it does require a degree of photographic knowledge to use it properly.

The highlight and shadow control functions of the T90 meter are operated by the two small buttons on the top right of the camera back marked with an upward pointing triangle and a downward pointing triangle. The third button, all the way to the right, is the exposure preview button, which turns on the viewfinder indicators. The downward pointing triangle indicates the shadow button while the upward pointing one indicates the highlight button.

To use this control, select a brightly illuminated part of the image and take a spot meter reading from it by aiming the central circle of the focusing screen onto that part of the image and pressing the spot metering button just behind and to the left of the shutter release button. Then press the highlight button (upward pointing triangle). Each time you press the button, the silver indicator arrow in the viewfinder will move upward by 1/2 EV step, up to a maximum of 4 EV steps.

Don't leave your camera at home when you go out in the evening. This photo required an exposure time of several seconds. The photographer was able to pull it off by supporting the camera on a railing while the shutter was open. Photo: Bob Shell

Shadow readings are made in the same way, except the reading is taken from a dark area of the image and the shadow button (downward pointing triangle) is used. This is where photographic knowledge is important, as you must know the range of the film you are using in EV steps and match the highlight and shadow readings to the capabilities of the film. As a general rule, black-and-white and color negative films have a much wider range than color transparency films. Photographers familiar with the Zone System will have no trouble understanding the metering system on the T90 and putting it instantly to use. If you are not familiar with the Zone System, there are many good books on the subject.

Open Aperture Metering

The light metering system of the T90 is designed to operate with the lens aperture fully open. The meter will work correctly for open aperture metering with all FD and FDn lenses. If you wish to preview the depth of field which will be produced at a set aper-

ture, you must take the lens off of the automatic setting and turn the aperture ring to the desired aperture. Then, press the stop-down button, located on the left front of the camera, in toward the lens. This will close the lens diaphragm down to the selected opening size allowing you to check depth of field visually in the viewfinder.

Stopped-Down Metering
Canon FL lenses plus some mirror lenses lack the aperture follower lug coupling that informs the camera of the selected aperture. Instead stopped-down metering, in which the light metering is performed at the actual working aperture, must be used. This type of metering can be done in the Manual or Av and P modes, and the camera will select the appropriate shutter speed to match the actual aperture in use. Stopped-down metering is accomplished on the T90 by pressing the stop-down (or depth of field preview) button on the lower left front of the camera in toward the lens prior to taking the meter reading.

Using stopped-down metering with autoexposure: When you must use an FL lens or any uncoupled lens or accessory with the T90 you can still get correctly exposed photos using the Av, Program or Variable Program mode. To use an uncoupled lens or accessory, press in on the depth of field preview button to activate the aperture display on the LCD panel and then operate the camera normally. There will be no display of f/stops in the viewfinder. Of course you must manually select the desired aperture on the lens, and the viewfinder will darken at smaller apertures. You may have to focus at full aperture and then close the lens down to take the photo. Over- and underexposure warnings still function in the stopped-down operational mode.

Stopped-down metering in manual mode: If, for some reason, you wish to use Manual metering with a non-coupled lens or with an FD or FDn lens in stopped-down mode, you should press the MODE button and use the electronic input dial to select Tv on the LCD panel. Release pressure on the MODE button and press in the stop-down button (depth of field preview). An M and the circular representation of a diaphragm are displayed on the LCD panel. In the viewfinder, the M will disappear from the display.

Metering on the center of the photograph won't always produce the best exposure. Use the spot meter to selectively set the exposure, then recompose the photograph if necessary. Photo: Bob Shell

Now set the desired shutter speed with the electronic input dial. One of three indicators, "CL," "OP" or "OO," will appear in the viewfinder. "CL" stands for close, and means that you need to close the lens aperture down to a smaller aperture (larger f/ number). Conversely, "OP" means that you need to open the diaphragm to a larger aperture (smaller f/ number). "OO" means that the exposure is correct. If "CL" is still displayed at the smallest aperture, you must select a faster shutter speed. If "OP" is still displayed at the largest aperture, you must select a slower shutter speed.

The only advantage to using this method is that the motor drive will run slightly faster in the high speed mode, since the camera does not have to take the time to close down the lens aperture.

Caution: *Although you can use stopped-down metering with most FL lenses, there are some exceptions. Due to mechanical design*

differences the FL 19mm f/3.5 and FL 58mm f/1.2 lenses can not be mounted on the T90. Attempting to mount these two lenses could damage the camera. The FL 19mm f/3.5 retrofocus, FL 35mm f/2.5, FL 50mm f/1.8 (version I), and FL 50mm f/1.2 (version II) lenses will fit onto the Canon T90, but will not work with the camera's light metering system at all. These lenses require the use of a separate, handheld meter to determine exposure and, thus, must be used only in the manual mode.

FD lenses with uncoupled accessories: When using FD lenses with bellows extensions or extension tubes which lack the aperture follower lug coupling, you must lock the diaphragm of the lens in stopped-down mode. Do this by sliding the chrome aperture coupling lever (which protrudes farther than the aperture follower lug) on the rear of the lens until it clicks into place. On older FD lenses, a switch must also be moved before this can be done. The lens is then mounted onto the accessory and the combination of lens and accessory is mounted on the camera. Metering and exposure is then accomplished by using stopped-down method. Late model FD and FDn lenses do not have a locking aperture lever, and must be used with the manual diaphragm adapter (Canon catalog number 18435).

When the diaphragm on an FD lens is locked in the closed position or when a non-coupled lens or accessory is attached to the T90, an M appears on the LCD panel where the aperture would normally be displayed to indicate that aperture coupling is inactive.

Exposure Control

Aperture and Shutter Speed Control

The T90 is designed so that all aperture and shutter speed settings are made by the same set of controls on the camera body. The range of aperture values varies from lens to lens. The widest aperture available in the FD system if f/1.2 while the smallest aperture is f/32. (Although there is one lens, the FL 1200 mm f/11, that stops down to f/64.) Lenses generally offer a range of seven or eight apertures. The shutter of the T90 offers a range of 18 different shutter speeds from a full 30 seconds to the very fast 1/4000 second.

Program Modes

Not only does the T90 have a standard Program mode, it also offers several Variable Program modes. To set the standard Program, press the MODE button and rotate the electronic input dial until PROGRAM appears on the LCD panel.

The Variable Program modes are tailored to match the lens in use. By turning the electronic input dial toward the right you can set a large P on the LCD panel in place of PROGRAM. In this position the camera will operate in the Variable Program mode. By continuing to turn the electronic input dial to the right you will see a 1 appear next to the P with TELE above. This is the telephoto variable program mode, designed for use with short telephoto lenses such as 85mm. In this mode shutter speeds of 1/60 and faster are favored. Turning the input dial to the right again will change the display to the P followed by a 2 with TELE above. This mode favors shutter speeds of 1/250 and faster, and is well suited to lenses in the 135mm to 300mm range. Turning to TELE 3 sets a mode that favors shutter speeds of 1/1000 and higher, and works best with lenses that are 500mm or longer. You can also use these modes with other lenses than those indicated when you want to limit depth of field by forcing the camera to select a wide aperture.

Starting at P and turning the electronic input dial to the left lets you access three WIDE programs, which are used to favor great depth of field. WIDE 1 favors 1/4 second, WIDE 2 favors 1 second, and WIDE 3 favors 4 seconds. These slow shutter speeds demand a tripod or other camera support. The following table will make the selections favored by the different Program modes more clear.

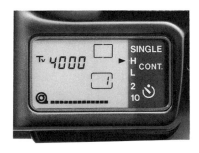

This LCD Panel indicates that the camera is in Shutter Priority mode (Tv) and that the photographer has selected a shutter speed of 1/4000 second.

Shutter Priority Mode

This mode can only be used with FD and FDn lenses or compatible lenses from other manufacturers. It can not be used with FL lenses or with uncoupled accessories, because in this mode the camera sets the aperture opening and must have the proper linkage to the lens to do so. The lens must be set for automatic operation, by setting the aperture control ring on the lens to either a green "A" or a green "O" depending on the lens.

To use Shutter Priority mode, press the MODE button on the left side of the camera and rotate the electronic input dial until Tv (for Time value) is displayed on the LCD panel. Once you have released pressure on the MODE button, you can then use the electronic input dial to set the shutter speed you wish. The speed appears on the LCD panel on top of the camera and in the viewfinder display, so you do not need to take the camera from your eye to change shutter speeds.

Whenever you switch to the Tv mode from another mode, the LCD panel always displays 125 (for 1/125 second) as a starting point. You must then select the shutter speed you actually want, if not 1/125 second, with the electronic input dial. Once you have selected the shutter speed you wish to use, the camera will automatically use the information from the metering system to select the proper aperture for accurate exposure.

Should an accurate exposure be impossible within the range of available apertures offered by the lens, the aperture indicator in the viewfinder display and on the LCD panel will flash as a warning. The camera will not prevent you from making the exposure, but the photo will probably be over- or underexposed. When you see this blinking display you should use the electronic input dial to switch to a different shutter speed until the blinking stops.

Using safety shift: In a rushed situation you may make use of the T90's safety shift feature by pressing both the ISO and EXP. COMP buttons on the back of the camera simultaneously and holding them for at least one second. This will activate the safety shift, indicated by SS in a black square in the LCD panel. The camera will switch to the first available shutter speed allowing correct exposure. For example, if you have set 1/125 second as the shutter speed and f/1.4 flashes because the lens can't open any wider, the camera would shift down to 1/60, 1/30, 1/15 or whatever speed

Use Aperture Priority (Av) mode to control depth of field in a photograph. Choose a small aperture for sharp focus from foreground to background and the camera will select a corresponding shutter speed for proper exposure. Photo: Bob Shell

would allow a proper exposure all the way down to 30 seconds if necessary. At the other extreme, if you had 1/125 second and an aperture of f/22 appeared and flashed, then safety shift would pick faster speeds all the way up to 1/4000 to ensure correct exposure.

The safety shift only operates in the Tv and Av modes and remains active until shut off by pressing the same two buttons that activated it.

Aperture Priority Mode

If you press the MODE button and rotate the electronic input dial until Av (Aperture value) is displayed, you will have set the T90 to Aperture Priority mode. This mode operates just the reverse of the previous one, and allows you to select any aperture you wish to use.

You may wish to use this mode when you want the extended depth of field offered by small apertures or with a large aperture

to blur a distracting background. I normally use the Av mode on my cameras when I wish to de-emphasize backgrounds in informal portraiture or glamour shooting.

Again, as with the Tv mode, you can make use of the safety shift described above to quickly choose exposure settings when the aperture you have selected does not match one of the available shutter speeds. If you do not use the safety shift, the shutter speed display will blink to warn of over- or underexposure situations.

Manual Mode

If you wish to set both shutter speed and aperture manually, as when working with electronic flash in the studio or using a separate hand-held light meter, use the MODE button and electronic input dial to set the camera to the Tv mode. Then use the electronic input dial to set the desired shutter speed.

On the lens you must take the aperture ring from its automatic position designated by either a green "A" or green "O" and set it to the desired aperture. When you turn this ring from the automatic position, the Tv on the LCD panel will change to an "M" and an "M" will be displayed in the viewfinder to indicate full manual operation.

This method makes a lot of sense when the aperture value and shutter speed will remain constant for a long series of photos, or for exposure situations in which automation will produce incorrect results.

The camera meter operates just as if the camera were still in the Tv mode and displays the aperture value selected by the metering system in the viewfinder and on the LCD panel. If you wish to use the meter's information, you would then manually set the indicated aperture. Alternately, you can select an aperture and set it on the lens and then adjust the shutter speed until that aperture is displayed. If the largest aperture value (lowest f/number) blinks in the viewfinder and on the LCD panel, this is a warning of overexposure. If the smallest aperture value (highest f/number) blinks it is a warning of underexposure.

Exposure Compensation

This is useful when you wish to apply compensation of a specific amount to a series of photos. To set the exposure compensation

first press the EXP. COMP button and then use the electronic input dial to set the amount of compensation desired. The range is from +2 to -2 EV in 1/2 EV settings. Following the earlier example of the A-1, these are indicated by 1/4, 1/2, 1, 2, and 4. 1/4 corresponds to -2 EV, 1/2 to -1 EV, 1 to normal exposure, 2 to +1 EV and 4 to +2 EV.

Inside the viewfinder a small + or - will be displayed to indicate that exposure compensation has been engaged. On the LCD panel the film loading stripes also blink as a reminder that exposure compensation is in use. The exposure compensation operates in the Program mode by altering both shutter speed and aperture. In the Av mode it alters only the shutter speed, and in the Tv mode only the aperture.

The exposure compensation effectively sets the metering system of the T90 to a higher or lower ISO speed. For this reason compensation over the full range is only available with films with speeds from ISO 25 up to ISO 1000.

Please note: You cannot use the exposure compensation in combination with the spot metering mode.

Flash Photography with the T90

Dedicated Flash Photography

The Canon Speedlite 300TL was introduced specifically for use with the Canon T90 camera, and is probably the best flash for use with this camera. The later Canon Speedlites made for the EOS cameras can be used with the T90 without sacrificing any of the camera's capabilities. The Speedlite 300TL is the first flash from Canon to sport four dedicated information-transmitting contacts on its flash foot which mate with similar contacts on the T90 hot shoe. Because of these four flash contacts, the T90/300TL combination is capable of greater autoexposure control.

With the 300TL Canon introduced a totally new concept in TTL flash operation. Called A-TTL (Advanced TTL), automatic fill flash operation in autoexposure modes became practical for the first time.

Also, the T90 was the first Canon camera to offer TTL-OTF (Through The Lens-Off The Film) metering. A small silicon cell in the base of the mirror box of the camera reads light reflected off

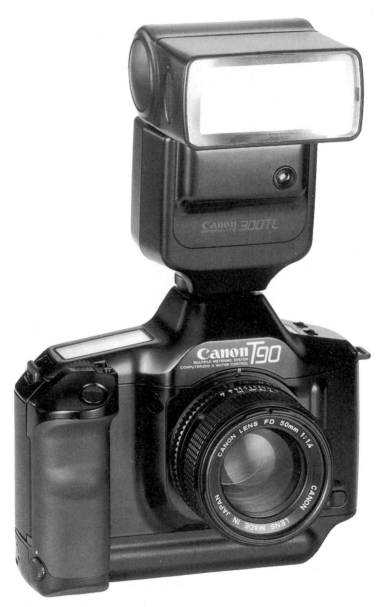

The Canon T90 with 300TL flash is a top choice among professionals who prefer a manual-focus SLR with sophisticated automatic features.

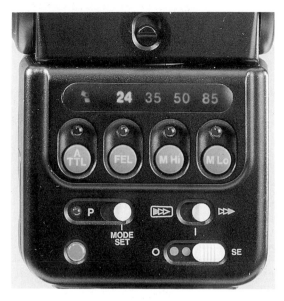

The 300TL was the first TTL flash unit introduced by Canon. Its zoom flash head corresponds to focal lengths of 24mm, 35mm, 50mm, and 85mm, and it featured automatic Through-The-Lens and spot flash metering.

the surface of the film and feeds this information to the camera's computer. This shuts off the flash tube after sufficient light has reached the film.

Please note: All of the operational modes of the Speedlite 300TL can only be used when the camera is fitted with an FD or FDn lens. Also it is important to make sure that the aperture ring of the lens is set to the automatic position when using the autoexposure modes of the camera/flash combination.

Fully Automatic Flash Control
After fitting the 300TL onto the T90, use the mode button on the flash to set it to P. The camera should also be set to PROGRAM. When you partially depress the shutter release button the flash will send out an infrared preflash, measure the infrared which is reflected back from your subject, and select an appropriate aperture/shutter speed combination which will be displayed in the

viewfinder and also on the LCD panel. If the display is constant, you can take the photograph. If the display blinks, then you are too far from your subject and must move closer to be within the range of the flash. Repeat the procedure to establish a new aperture/shutter speed combination that does not blink on the display.

The 300TL flash has a head that tilts and rotates. With the head in the normal position, the flash will send out an infrared preflash when the shutter release button is pressed half-way down. A red LED will light if the camera's computer system has verified that sufficient light will be provided for proper exposure. If the flash head is tilted or rotated, the flash ceases to use the infrared preflash, and instead emits a visible preflash from the flash tube with about 1/20 the power of the actual flash. This measures if the flash is sufficient for proper exposure.

Advanced TTL Operation
A-TTL flash: To operate this mode press the A-TTL button on the flash and move the MODE SET button to the right until the P disappears from the flash display.

A-TTL plus Program mode: Set the flash as above and set the camera for Program. In this mode the flash and the ambient light will both be measured and a compromise setting will be calculated by the camera to provide the best mix of the two light sources. This mode works well for the majority of photographs.

A-TTL plus Shutter Priority: Set the flash for A-TTL as above and set the camera to Tv. This allows you to select any shutter speed up to 1/250 second manually, and the flash and camera will work together to set the appropriate aperture and amount of flash. If the aperture value flashes, then you must select a slower shutter speed for proper exposure.

A-TTL with Aperture Priority: Set the flash for A-TTL as above and set the camera to Av. This allows you to select an aperture and the flash automatically sets the camera's shutter speed to a sync speed of 1/250 second or slower. If both the aperture and shutter speed displays in the camera's viewfinder flash, then the distance is too great for the aperture you have selected. You must either move closer or select a larger aperture. If only the shutter speed flashes,

To properly expose both the statue and the flowers in the foreground, the photographer moved back to increase the flash-to-subject distance. This minimized the relative distance between objects in the scene for more even flash exposure.

this means that areas of the image that are beyond the range of the flash will be underexposed. If you are only concerned about areas within the flash range, you may ignore the flashing shutter speed. However, if you want the entire scene to have proper over-all exposure, then select a larger aperture, move the subject closer to the background or, if possible, place it in front of a different background.

Flash with Manual Mode
When the camera is used in manual mode the photographer sets both the shutter speed and aperture, A-TTL does not function and the system does not balance ambient light and flash. It is up to the photographer not to set a shutter speed faster than 1/250 second.

Even though the A-TTL does not function, standard TTL does. The main subject will be properly exposed as long as it is within the distance range of the flash for the aperture you have selected.

FEL Flash with Exposure Lock

This is selected by pressing the FEL button on the flash. In this setting the preflash which is used to measure flash exposure is only triggered when you press the spot metering button on the camera. The part of the image that is measured, in this case, is the area within the microprism ring on the camera's focusing screen. The flash reading taken in this way is stored and held for the subsequent photo.

FEL Flash with Program Mode

When you use the FEL system with the T90's Program or Variable Program modes, the calculated shutter speed and lens aperture are displayed in the viewfinder. This occurs when the spot metering button is pressed and the preflash measures the flash output. An illuminated dot next to the silver arrow on the spot metering scale confirms that the light from the flash is sufficient for proper exposure. If the dot does not appear, the distance is too great and you must move closer to your main subject.

FEL Flash with Shutter Priority Mode

With the flash set for FEL and the camera set for Shutter Priority, pressing the camera's spot metering button causes the preflash to fire. The camera then calculates an appropriate aperture and stores it for up to 30 seconds. An illuminated dot will appear on the spot metering scale in the viewfinder to indicate sufficient light for correct exposure of the main subject. The silver arrow will also appear, and the distance between the arrow and dot indicates the lighting ratio between the flash exposure and the ambient light exposure.

Tulips photographed with the Canon T90 and 300TL flash. A wide aper- ⇨
ture was selected in Aperture Priority mode. The background contrasts
nicely with the flowers because it was far enough away from the tulips to
not be illuminated by the flash.

You may use the highlight and shadow buttons to bias the exposure. This alters both the flash and the ambient light exposure. Both the dot and arrow will move on the scale but they maintain their positions relative to one another. Turning the electronic input dial moves only the lighted dot, allowing you to select the ratio of flash to ambient light.

FEL Flash with Aperture Priority Mode
Just as described above, pressing the spot metering button with the flash set for FEL and the camera set for Av causes a preflash to be fired, measured and stored. The illuminated dot again appears to indicate that there will be sufficient light from the flash for proper exposure. However, in this mode the silver arrow on the spot metering scale can be used with the meter set for center-weighted average, selective metering or spot metering. It measures accordingly and it responds to the ambient light, not the flash. If the silver arrow lines up with the central pointer, then the flash brightness and ambient light are in perfect balance.

If the silver arrow does not line up with the central pointer, you can bring it to this position by using the highlight and shadow buttons which fall conveniently under your right thumb. If the illuminated dot is not lined up with the central pointer, then you must pick a different aperture if you want the flash and ambient exposure to be balanced. You may or may not want this depending on the type of photo you are attempting to produce. This allows you to vary the brightness of the background against the main subject, making it lighter or darker as you choose. Many unusual and creative effects are possible with this combination of Av and FEL modes.

Manual Flash Control
In addition to the automatic modes described above, the 300TL flash may also be used in the Manual mode. On the flash, M-HI for high-power Manual flash mode or M-LO for low-power Manual flash mode can be selected. These are easiest to use in Av or Manual camera modes.

To use these Manual modes you must refer to the flash unit's guide number table and divide the stated guide number by the distance to the main subject to determine the correct lens aperture.

Other Canon Flash Units

With flash units from the Canon Speedlite A- or G-series, fully automatic flash exposure is possible on the T90. Fully automatic operation is also possible with Canon dedicated flash units from other manufacturers. These flash units will select the proper aperture automatically, assuming that the aperture ring on the lens is set in the automatic position, and will also automatically set the camera's shutter speed to 1/90 second. When the flash is ready to fire, the lightning bolt flash symbol will appear in the viewfinder. These flash units measure exposure with the sensors on the front of the flash unit and do not provide TTL metering.

With flash units from the Canon Speedlite T-series, the aperture ring on the lens must be taken off the automatic position and the lens aperture must be set manually. A red "M" will flash inside the viewfinder as an indication that you must set the lens aperture manually.

Non-System Flash Units

Other non-dedicated flash units may be used with the T90, but care must be taken so that they will not damage the camera. Older flash units with high trigger voltage must never be used on the T90 as they will damage the camera's electronic systems. The best rule of thumb is, if you are not sure, do not try it. It is not worth ruining a very fine camera by using it with an improper flash unit. If you have a question, ask a knowledgeable Canon dealer or call Canon customer service.

Using Studio Flash

The one glaring omission on the Canon T90 is the complete absence of a PC socket for use with studio flash units. This was probably left off because the T90 uses an electronic flash switch rather than a mechanical one, and flash units of reverse polarity (of which there are many among studio flash systems) would either not work with the camera or, worse yet, damage it.

The best solution to this problem is not to use a hot shoe to PC adapter, because this simply bypasses the safety in the camera design. The only good solution for firing studio flash with the T90 is to use a wireless remote flash triggering system. One of the authors, Bob Shell, recommends the Wein SSR and Pro-Sync systems which he has used for many years. He uses them in his

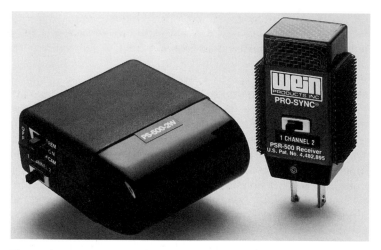

The Wein Pro-Sync transmitter (left) mounts in the camera's hot shoe and sends out coded pulses of infrared light when the shutter release button is pressed. The receiver (right) connects to and triggers the flash unit when it detects the infrared pulses.

own studio and in his photo workshops. They can not damage the T90 or any other modern electronic camera, and they will dependably fire any type of flash unit. They operate by transmitting an infrared pulse from a transmitter mounted on the camera's hot shoe to a receiver mounted on the flash.

Additional Features

The "B" Setting

By pressing the Mode button and turning the electronic input dial until the word "Bulb" is displayed on the LCD panel, you can set the camera to "B" or "Bulb" mode. Once this has been set, pressing the shutter release button will open the shutter and it will remain open as long as pressure is maintained on the shutter release button. Additionally, the camera will indicate the exposure time in full seconds on the LCD panel, counting numerically up to 30 seconds and then resetting to 1 second, and counting to 30 again. For each 30 seconds counted, a bar of three dashes will appear at the bottom of the LCD panel. This system makes it

possible to count up to 120 seconds with the camera's timer. Of course, you can make much longer exposures if needed, but you will have to time them with an external timer.

Self-Timer

To set the camera's self-timer, open the door on the right-hand end of the camera and turn the bottom rotary switch counterclockwise to the self-timer indicator, which resembles a clock face. Next, check the LCD panel on the top of the camera to make sure that the arrow indicator has moved to the lower self-timer position and points to 10. This indicates a ten-second delay. If you want to use the shorter, two-second delay, press the tan colored button in the center of the rotary switch which will move the indicator arrow up to the number 2 on the LCD panel.

Once you have set the self-timer, pressing the shutter release button in the normal manner will activate it. The countdown is indicated digitally on the LCD panel and by a bright, flashing red LED on the front of the camera. This LED flashes slowly for the first eight seconds of a ten second countdown and then flashes rapidly for the final two seconds. If you use the shorter, two-second timer, the LCD panel only counts from two and the LED flashes rapidly for the full two seconds.

Multiple Exposures

By pressing the Mode and Metering/Clear buttons simultaneously, you can access the camera's multiple exposure mode. You will see ME in a black rectangle on the LCD panel along with the number 1. By rotating the electronic input dial you can set up to 9 exposures on a single frame of film. The motor which cocks the shutter is active in this mode, but the film advance motor is not activated. If you wish to make more than nine exposures on one frame, you can do so by setting the ME counter for nine and taking only eight frames, and then resetting the ME counter again. You may do this as often as needed to achieve the number of exposures you require.

You must remember that for most subjects it is necessary to make an exposure compensation based on the number of exposures being made on a single frame of film. If you are putting two exposures on a frame, then it is recommended to underexpose each of exposure by one stop. Because this is often an imprecise

To select the exposure mode use the mode button. The metering/clear button selects the metering mode. Pressing both simultaneously allows the photographer to take multiple exposures.

art, I recommend making multiple exposures on color negative or black-and-white film rather than transparency film. Because of their exposure latitude, black-and-white and color negative films will still allow good prints to be made even if the exposure is not quite correct.

The exception to this rule of exposure compensation is when your subjects are photographed against a black background and do not overlap in the multiple exposures. In this specific case no exposure compensation is necessary.

You may also combine the Multiple Exposure mode with continuous film advance for a simulated stroboscopic effect.

Canon Accessories
With the T-90, you can use A-, G-, and T-series Canon Speedlites with automatic flash exposure. The Speedlite 300TL and the Macro Ring Lite ML-2 offer only TTL flash metering. Eyesight correction (diopter) lenses are available to fit the T-90 eyepiece.

The Data Back 90 and Data Command Back 90 are two different data backs which allow imprinting of information onto the film during exposure.

In order to make the sky appear darker and contrast with the white ⇨ clouds, a polarizing filter was used. The filter reduced the amount of light hitting the film, but through-the-lens metering compensated for this.

Canon Lenses

At the time the A-1 was introduced, there were more than 40 FD lenses in the Canon catalog. By the launching of the T90 this had grown to over 60 FD lenses. When the EF lenses were introduced for the EOS cameras, development of new FD lenses was continued for a short time and then halted. However, one truth remains: the FD lenses were all exceptionally good lenses for their time, and older cameras with FD lenses can take excellent photographs.

The FD Bayonet Mount

The FD lens mount, introduced concurrently with the original Canon F-1 camera, was an evolutionary advancement over the previous FL mount. FD lenses fit and function properly on all Canon cameras from the FT and TL models all the way up to the T90, the last camera to accept the FD mount.

Spring-driven diaphragm: Canon SLR lenses feature an automatic diaphragm system in which a spring drives the diaphragm to close down to the desired aperture just before the photo is taken. This allows focusing at the lens' widest aperture, which delivers the brightest image to the focusing screen and, because depth of field is smallest at this wide aperture, makes focusing more precise. This system was offered on Canonflex lenses, FL lenses and, of course, on FD lenses.

Aperture simulator: On FL lenses, the diaphragm was closed down by pressing a lever on the camera body prior to taking a light meter reading. This is usually referred to as stopped-down metering or working aperture metering. It is a very accurate form of metering since the meter reading is taken at the actual aperture setting used

↩ **The increased contrast in the sky in this scenic shot was achieved by using an orange filter. Without the filter, the sky would have been rendered light gray and the clouds would not have been visible.**

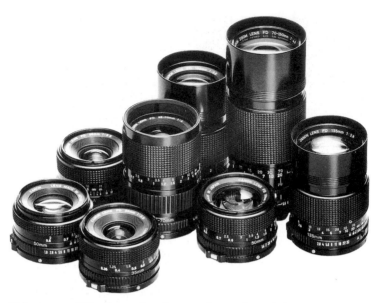

This group of FDn lenses is only a small sampling of the more than 60 lenses available. When Canon improved its FD bayonet mount, it changed the chrome ring to black and incorporated new technology to make the lenses smaller and lighter weight.

for the exposure, but it is somewhat slow in operation. The FD lenses improved on this by having a moving lug on the back of the lens which changes position as the aperture ring is turned. This lug engages with a lever inside the camera and passes to the light meter the aperture which has been set on the lens. This system allows taking meter readings with the lens wide open regardless of the aperture at which the photo will be taken, which makes for a faster response. Theoretically, it is less accurate than stopped-down metering, but on a well-made system such as used by Canon the deviation between a stopped-down meter reading and one taken at full aperture is negligible, and well within the latitude of even the most sensitive film.

Lens mount: FL and FD lenses mount onto Canon camera bodies in an unusual manner. A quick glance at one of these lenses shows that their most striking feature is a large, knurled chrome ring at

The FD bayonet mount: In the camera and on the lens mount you can see the various control levers that are used to stop down the aperture of the lens.
The photo at right shows the lens' focusing scale in feet and meters, the depth of field scale and the range of f/stops. The "A" to the right of f/16 is the automatic position.

the rear of the lens. Unlike almost all other cameras in which the lens is fitted to the camera and then turned to lock it in place, the Canon FL and FD (and Canonflex as well) lenses are simply fitted straight onto the camera, and then this chrome locking ring is turned to fasten them firmly in place. The actual mating surfaces which determine lens-to-film distance and alignment do not turn against one another. This system eliminates wear on these parts. In theory, a Canon lens of this type should maintain accurate alignment long after a traditional bayonet has worn out. Actually, Canon must have decided that this was not a serious consideration since they reverted to a standard bayonet on their EOS cameras and EF lenses.

In 1979 Canon changed to a new type of FD bayonet, which has unofficially been called FDn. The chrome ring no longer adorns the rear of these lenses, which are now completely black in finish with a large chrome release latch button on the rear ring of the lens. Unlike the FD lenses, these new FDn lenses mount

A typical scene has light and dark areas that average out to medium gray. Therefore, camera meters are calibrated to set exposure as though every subject were middle, or 18%, gray.

directly onto the camera as before, but are locked in place by turning the entire lens. Interestingly enough, the mating surfaces still do not move against one another, since the rear barrel section of the lens does not turn when the rest of the lens is turned to lock it on the camera. The chrome release latch must be depressed to remove one of these lenses from the camera.

The other difference in these new FDn lenses is that much of the metal used in the earlier lenses was replaced with plastics, and new optical designs were developed, making these new lenses both smaller and lighter than those they replaced. Although there were predictions at the time that these new lenses would not hold up as well as the earlier, all metal, ones, this has not proved to be the case. Both types of lenses have survived about equally well and are available on the used market.

This scene was beyond the film's latitude, and every element could not be reproduced with detail. The photographer set the exposure for the trees in the foreground and allowed the hazy background and sky to be slightly overexposed.

Lens Accessories

Lens caps: Whenever Canon lenses are not mounted on the camera, they should always be protected by front and rear lens caps. These prevent dust and grit from getting into the lens' rear mechanism or on the glass elements where they can accumulate and degrade optical quality. If you must set a lens down without a lens cap, always put it face down to avoid possible damage to the diaphragm linkages which protrude from the rear of the lens.

Lens hoods: When using any lens, it is recommended that you use a lens hood or lens shade on the front. The purpose of this is to keep stray light from entering the lens where it can reflect from surface to surface causing image-degrading flare. The lens hood

should be the proper one for the lens in use so that it will effectively block stray light without intruding into the image and causing dark corners or vignetting.

Because they typically have more elements and thus, more surfaces to reflect stray light, it is particularly important to use lens hoods with zoom lenses. Canon offered a range of bayonet mount lens hoods matched to their lenses. These nicely-designed, matched hoods are always preferable to the common generic lens hoods if you can find them. Lens hoods for zoom lenses are always a compromise since they must be designed for the widest angle covered by the lens and do not function nearly as well at the longer zoom settings. Thus, you must be much more careful to avoid lighting situations which cause flare when using zoom lenses.

Lens Coatings

Because each air-to-glass surface within a lens is a potential source of reflection, lenses with more than four elements are very prone to flare, or "veiling glare" as it is more properly called. Lens designers have always had to make compromises to keep the number of lens surfaces to a minimum

In 1936, Zeiss scientists invented a process of vacuum depositing a very thin layer of calcium fluoride or magnesium fluoride onto the surfaces of lenses, a process which greatly reduced the surface reflectivity in the middle of the visible spectrum and allowed the use of more lens elements while still controlling flare and holding it to an acceptable level. Canon has coated its SLR lenses in this manner from the beginning in order to control flare.

With the introduction of FD lenses in the early 70s, Canon began to use a new process which deposits multiple thin layers of different substances onto the lens surfaces, effectively controlling reflection throughout the spectrum. Such lenses were marked "SC" (Super-Coated) or "SSC" Super Spectra-Coated. While the exact number and composition of the layers of coating is a closely-

Shutter Priority mode should be used when the photographer wants to **convey motion. Choosing a shutter speed of 1/15 second caused the water from this fountain to blur slightly, making it appear to be flowing rather than frozen in space.**

This long exposure was shot using a tripod and a wide-angle lens. The star filter added an appealing touch of drama.

guarded secret, some firms have acknowledged that they use as many as seventeen layers on some of their lenses.

Suffice it to say that Canon engineers design the coating for each lens element based on the demands to be placed on the lens, and to achieve the lowest possible reflectivity. This does not completely eliminate the possibility of flare. Some results from the use of cemented doublet and triplet lens components (cemented surfaces can not be coated). Flare is also caused by the edges of the lens elements and by reflection from the inner surfaces of the lens barrel. So even SC and SSC lenses are not impervious to flare and should be used with the appropriate lens hoods.

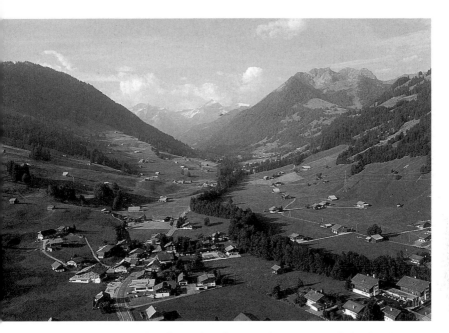

Aperture Priority mode allows the photographer to control depth of field in a picture. For this scenic landscape, using a small aperture kept every detail sharp from foreground to background.

Zoom Lenses

Zoom lenses are very versatile and can be the ideal solution to many photographic problems. However, because zoom lens technology has progressed very far in recent years, early zoom lenses do not have the optical quality required for professional-level photography and are best avoided. Later model Canon zoom lenses in the FDn lens mount are as good or nearly as good as the best zoom lenses made today, and may be purchased and used with confidence. The convenience of a zoom lens, the ability to quickly shift from a wide-angle to a normal focal length, and then on to a telephoto, often makes it possible to capture images which would otherwise be lost while the photographer was changing lenses. Because one zoom lens can replace several fixed-focal

Perspective distortion this dramatic is created with a super wide-angle lens. Tilting the camera up exaggerates the apparent convergence of lines.

length lenses, using a zoom lens or two allows you to carry a smaller and lighter camera bag.

Because it is very difficult to design a zoom lens with a really broad range, no FD-mount zoom lenses go from very wide-angle to extreme telephoto. At best, you will find a lens offering moderate wide-angle through normal to moderate telephoto. For this reason, many photographers use a system made up of two or three zoom lenses to completely cover the range of focal lengths they need for their photography.

Also, zoom lenses cannot be made fast, that is with very wide maximum apertures, without at the same time making them physically very large. Most zoom lenses are limited to moderate maximum apertures in the range of f/4.5 and smaller. This means that you will have to use faster film or carry a tripod if you wish to take photos in low light.

Canon 70-150mm f/4.5-5.6 lens

There are two main types of zoom lenses, distinguished by their control systems: The first type is called a "push-pull" or "trombone" style zoom. In this design there is only one big grip ring which is turned to achieve focus and pushed and pulled to change the focal length. This type of lens is preferred by many photographers for shooting fast action, since the photographer never has to change his or her grip on the lens. On the other hand, it is difficult with this type of zoom to maintain focus while changing focal length, since the tendency is to turn the ring some while accomplishing the push/pull action. A favorite photographer's trick is to zoom out to the longest focal length to focus on detail, then pull back to a more moderate focal length to take the photo, and this, too, is very difficult with this sort of zoom.

The second type of zoom lens uses two separate rings on the lens barrel, one controls focus and the other controls the zoom action. With practice, it is possible to use this sort of lens nearly as fast as the push/pull type, plus it has the advantage that focus or focal length is unlikely to be changed by accident. Canon has offered both designs in their range of zoom lenses.

Normal Lenses

So-called, normal or standard lenses are named for their approximation to the perspective seen by the human eye. Photos taken with them appear to be natural and without distortion, having neither the expanded perspective of wide-angle lenses nor the

With only one or two zoom lenses, an extensive range of focal lengths from extreme telephoto to wide-angle are available. The only drawback

compression of telephotos. They make good all-around lenses, and because they used to be supplied with most cameras as standard equipment, they are inexpensive and easy to find in camera stores' "used equipment" cases.

A normal lens is usually defined as having a focal length that is approximately the same as the diagonal measurement of the film. With 35mm film, the frame measures 24 x 36 mm and has a diagonal of about 43-1/4 mm. Because viewers have judged that the perspective of a 44mm lens looks slightly wide, camera makers standardized some years ago on 50mm lenses as nominally "normal" lenses.

Because lenses in this focal length range use relatively simple optical formulas with high image quality, it is also possible to make normal lenses quite fast without making them physically large and heavy. The most common Canon normal lens is the 50mm f/1.8 FD. For those who require a lens with a larger maximum aperture

to zoom lenses is they generally aren't as fast as fixed focal length lenses.

Canon FD 50mm f/1.8 lens

When you want to capture the subject quickly without thinking about exposure settings, choose Program mode.

for low-light photography or easier focusing, Canon has also offered normal lenses with maximum apertures of f/1.4.

Canon also designed the 50mm f/1.2 which was made in two versions. The first version was a standard 50mm f/1.2 FD lens, while the second was a very expensive 50mm f/1.2 L version which used hand-ground, aspheric elements to achieve maximum optical quality when the lens was used wide open. This lens is a rare find today.

Don't dismiss a standard 50mm lens as being "boring." It is the ⇨ **photographer's creative intent that makes the picture, not the lens used.**

Canon FD 35mm f/2.8

This reflection of a church in the windows of this office building creates an interesting, graphic image. Because the camera was tipped up to photograph the building, the vertical lines appear to not be parallel. Using a wide-angle lens accentuated this distortion.

Wide-Angle Lenses

Lenses with a shorter focal length than "normal" lenses are designated as wide-angle lenses. For the purposes of this book, we are considering all lenses between normal and 24mm focal length as wide-angle lenses. Commonly, lenses with focal lengths shorter than 24mm are classified as either super wide-angle or fisheye lenses.

35mm lenses: Many photographers find the 35mm focal length ideal for their purposes. While being wider than a normal lens, it is not so wide that distortion is a problem and thus, is much easier to use than wider lenses. For many photographers, particularly photojournalists, it has replaced 50mm as the "normal" lens.

A 35mm lens is excellent as a snapshooter's lens since it can be used for very fast grab shots without the need for critical framing. Framing can be done after the fact by selectively enlarging portions of the negative (called "cropping"). The 35mm focal length is also very good for group shots. Many photographers prefer this focal length for landscapes and still life photos also. Interior photos, particularly indoor photos with flash, often come out very well when taken with a 35mm lens. (With the flash set for wide-angle if it has a zoom reflector, with a bounce card, or by bouncing the flash off a wall or ceiling.)

Over the years, in the Canon program, there have been several 35mm lenses. The 35mm f/2.0 FD is particularly popular as a fast wide angle. There is also the FD zoom 35-70mm f/4, which offers the 35mm focal length as its widest zoom setting. The FDn 35mm lens in its second generation, without the rear chrome ring, is particularly good.

28mm lenses: The 28mm lens has a wider, 74° angle of view. This is particularly nice when you want to get the entirety of a large scene into the photo and do not have room to back away from it. This focal length must be used with care, however, since perspective distortion begins to be a problem. The effect of "stretching" subjects and line curvature near the edge of the frame can be a problem when the lens is tilted up or down.

However, like the 35mm, the 28mm lens is ideal for group shots and fast snapshots.

Canon offered a 28mm f/2 and a 28mm f/2.8 in their FD lens

An environmental portrait of a building: The photographer used a wide-angle lens to photograph this cathedral and its surroundings including the crowded walkway in the foreground.

Canon FD 28mm f/2 lens

line. They have also manufactured a 28-85mm f/4 FD zoom lens and a 20-35mm f/3.5 FD L lens, which also includes the 28mm in its range.

24mm lenses: Many problems are caused by the 84° angle of view of the 24mm focal length. In landscapes, it can make the sky too large and overwhelming, and it is difficult to keep the sun and the

Canon FD 24mm f/1.4 L lens

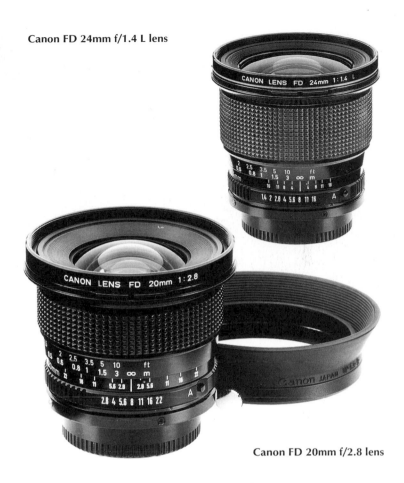

Canon FD 20mm f/2.8 lens

lens flare that accompanies it, out of the photo. Unless the lens is kept absolutely vertical, the lines of buildings in architectural photographs will tend to show strong converging verticals, making it appear as if the buildings are Hollywood sets falling over backwards. In both landscape and architectural photos, subjects close to the lens will tend to appear disproportionately larger that background subjects. Giant mountains turn into little hills when photographed with a 24mm lens.

Because of these "problems," a 24mm lens is not generally considered to be a good all around wide-angle lens. However, this

Using a Canon FD 24mm lens enabled the photographer to exaggerate the canal's perspective, drawing the viewer's eye into the picture and highlighting the building in the distance.

focal length can be very effective in rendering grand scenes or when exaggerated perspective is desired for effect.

Canon offered two different 24mm lenses in its FD lens line-up over the years: the super fast 24mm f/1.4 FD L which was very expensive when new, and the more moderately priced 24mm f/2.8 FD. Both are very good lenses.

Super Wide-Angle Lenses

Lenses with focal lengths shorter than 24mm are considered to be "super wide-angle" lenses. In its FDn lens program, Canon manufactured lenses with focal lengths of 20mm, 17mm and 14mm. In the older FD mount with the chrome attaching ring, Canon offered a 20mm f/2.8 FD and a 17mm f/4 along with a very expensive 14mm f/2.8 FD L, a remarkably sharp lens with minimal distortion.

Landscapes and grand interiors are the domain of these lenses, particularly when used at small aperture, with a tripod and a small bubble level in the camera's flash shoe, for great depth of field. The FD zoom 20-35mm f/3.5 FD lens must also be included in this group, since it stretches to 20mm at its shorter end. When the greatest possible angle of view can make the difference, these lenses are a photographer's dream.

Canon 7.5mm f/5.6 Fisheye lens

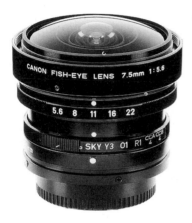

Fisheye Lenses

Canon offered two different fisheye lenses in its FD series. These are the 15mm f/2.8 FD and the 7.5mm f/5.6 FE, the shortest focal length offered by Canon. The 7.5mm FE lens lacks light meter coupling and must be used with a separate, hand-held meter.

Fisheye lenses come in two types, full-frame which fills up the whole 35mm frame and has a diagonal angle of view of about 180°, and the circular type which projects a full circular image with a 180° angle of view into the middle of the 35mm frame. Canon's 15mm fisheye is the full-frame type, while their 7.5mm fisheye is the circular image type. Both have such a wide-angle of view that the photographer must always be careful to make sure that feet, tripod legs or camera straps don't intrude into the image.

Fisheye lenses are obviously for special effects only. They were originally invented for use in weather forecasting, since, when pointed straight up, they capture the entire sky to record the

clouds. Anything seen through a fisheye lens will have a new perspective, and they are certainly a lot of fun to play with when looking for a fresh point of view for any subject. These lenses are expensive even if you are fortunate to find one on the "used market". Because of this and the highly-specialized nature of the these lenses, many professional photographers in larger urban areas rent fisheye lenses when they have an assignment that requires their use.

Telephoto Lenses

While not strictly accurate from a technical point of view, all lenses longer in focal length than 50mm are commonly called "telephoto" lenses. Just as with wide-angles, we will divide telephoto lenses into standard telephoto, starting at about 75mm and extending up to about 300mm. Lenses longer than 300mm we will call "super telephoto." Lenses in the Canon FD system go all the way up to 800mm.

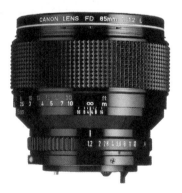

Canon FD 85mm f/1.2 lens

85mm to 135mm lenses: Perhaps the most frequently-used group of telephoto lenses, lenses in this range are generally called "portrait" lenses. This is because they are perfect for head-and-shoulders photos that have a pleasing and flattering perspective. When using a "portrait" lens, a photographer can maintain a good working distance without crowding the subject by getting too close. The perspective is slightly compressed, but not dramatically so, and noses and ears are rendered at proper proportion to the rest

Getting low and pointing the camera up at a subject causes parallel lines to appear to converge.

of the face, unlike shorter lenses which tend to make the nose too large and the ears too small when the photo is taken up close for a tightly cropped portrait. These lenses also make it easy to isolate the subject from the background, since they may be used at wider apertures and completely blur the background while keeping the portrait subject within the area of sharp depth of field. These lenses are also good for landscape and nature photography when used to isolate details of a landscape or nature subject rather than including the whole thing.

A typical example of this sort of lens is the Canon 85mm f/1.8 FD found in the original FD version with the chrome attaching ring. Also the 100mm f/2 FD is an excellent, short telephoto.

For portraits, many photographers consider the 135mm lens to be just a tiny bit too long, while others think it is just right. This is a personal decision of the photographer. The 135mm f/2 FD is a remarkably agile and fast lens for snapshots and general photo-

A telephoto zoom set at 200mm was used to document the detail in this distant carnival ride.

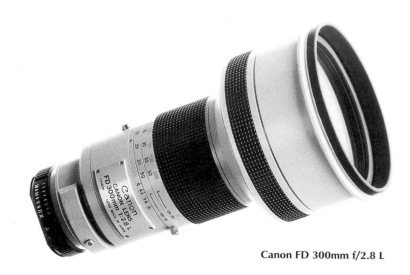

Canon FD 300mm f/2.8 L

journalism. You can fill the frame with a subject at a moderate distance. The fast, maximum aperture allows you to easily control depth of field and, when desired, isolate the main subject from the background.

Also in this general group is the FD zoom 70-150mm f/4.5 FD. A very nice two-lens outfit can be put together with this lens and the 28-85mm f/4 FD lens, or even with the 35-105mm f/3.5-4.5 FD. An outfit like this is ideal for travel, since the two lenses can fit into a very small case and will handle almost any photographic situation the photographer is likely to encounter.

200mm to 300mm lenses: These lenses are ideal when a smaller subject area must fill the frame or when the photographer wants to isolate small detail from the whole scene. They also offer a much more compressed perspective, which can be quite useful photographically for certain effects. Canon offered the 200mm f/4 FD, the 300mm f/5.6 FD and the 300mm f/2.8 FD L lenses in this range, along with the 80-200mm f/2.8 FD and 100-300mm f/5.6 FD zooms.

These lenses are ideally suited for sports, wildlife and photojournalism. They may also be used to produce startling images with compressed perspective, such as a row of cars in a parking lot that seem to be pressed together. Many fashion photographers prefer to work with long lenses like these to enlarge the background detail behind the models while blurring it by taking advantage of the lens' very shallow depth of field as a creative tool.

Super Telephotos Lenses

In this category we find the very specialized Canon 800mm f/5.6 FD L lens which weighs 4,400 grams (about ten pounds)! Also in this group is the spectacular 150-600mm f/5.6 FD L zoom lens. These are the lenses used at sporting events to isolate the football player on the field, the baseball pitcher on the mound, or for spectacular images of wildlife. They are taken on photo safaris in Kenya, used for scientific research, or to make photos in which the sun is a giant glowing ball. For most amateur photographers these lenses are too big, too heavy, and too expensive.

Special Purpose Lenses

As part of its corporate philosophy, Canon has always offered a variety of lenses for special purposes. This has attracted many specialist photographers to Canon system since some of these lenses are unique to the Canon line-up.

Macro lenses: Macro lenses are used for extreme close-up photos with reproduction ratios from 1:2 (the subject half life size on the film) down to 1:1 (the subject life size on the film). A particularly remarkable lens is the 200mm f/4 FD which combines a good, general purpose telephoto lens with a very fine macro lens. The extra focal length allows highly magnified photos of small insects and animals from a comfortable distance, making it less likely to frighten away the subject.

Bellows lenses: These are special versions of macro lenses lacking a focusing system of their own. They are made specifically to be used with extension tubes or particularly with a focusing bellows for extreme close-up photography. They are not often encountered and are essentially restricted to scientists and specialists in close-up photography.

Tilt/Shift lenses: Canon is the only camera company offering tilt/shift lenses, called "TS" for short. A number of camera firms offer shift lenses, sometimes called architectural lenses, because their most obvious use is to shift the lens up to capture tall buildings without distortion. The Canon TS 35mm f/2.8 is as versatile for this purpose as any other shift lens on the market, but that is not all it does.

In addition to shifting, this lens also tilts. You may wonder why anyone would want to tilt a lens, and the answer is to make use of the Scheimpflug Principle. Scheimpflug discovered that a plane through the film and plane through the lens would come together along a line if the lens is tilted. When this is done the plane of focus also converges along this same line. Effectively, tilting a lens

⟵ **A tilt/shift lens is useful for photographing architecture. By keeping the film plane parallel to the building and using the shift feature, the entire building was included in the frame with no distortion.**

allows you to tilt the plane of focus. This allows you, in many cases, to get a whole subject in focus without stopping the lens down to a small aperture. An obvious example is a landscape in which a downward tilt of the lens allows you to get foreground, middle ground and background all in sharp focus with the lens wide open.

Equally, the tilt can be used to throw things out of focus. You could have three people standing in a line, all at the same distance from the camera, and by using the tilt sideways (in which case it is properly called a swing) you could keep the person in the center in sharp focus while throwing both other people out of focus. You see this effect used today in advertising when a central part of the product is in sharp focus while both ends are out of focus.

The Canon Tilt/Shift lens allows you to do many things to move up that could otherwise only be done with a large studio view camera.

Soft-focus lenses: Canon offers a special 85mm f/2.8 FD SF lens. This lens is a normal 85mm portrait lens when used with the focus

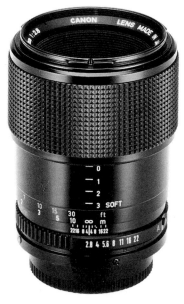

Canon FD 85mm f/2.8 Soft Focus lens

ring set to the 0 position. In this setting, it may be used like any other medium telephoto lens.

However, it also offers three different settings for soft focus. These settings shift the internal arrangement of some of the lens elements to produce varying degrees of softness in the final image. This lens is particularly popular with photographers specializing in glamour, moody portraiture, nudes, still-lifes, etc.

Extenders: Also called tele-extenders or teleconverters, these lenses magnify the image produced by a lens just as Barlow lenses do with telescopes, increasing the effective focal length in the process. For example, a 2x teleconverter coupled to a 200mm lens will produce an effective 400mm lens. However, there is always a price to pay, and in this case it is two f-stops loss of light. So a 200mm f/4 would be converted into a 400mm f/8.

There is also a 1.4x teleconverter, which increases the focal length of a lens by a factor of 1.4 and only loses one f/stop. This would turn the 200mm f/4 into a 280mm f/5.6.

Electronic Flash

Canon has a long history of innovation in electronic flash automation. The FTb and F-1 cameras all were designed to work with the CAT (Canon Auto Tuning) flash system, which automatically matched the proper aperture to the focusing distance with a match needle indicator in the viewfinder. This system was highly innovative for its day, and actually produced more accurate flash exposures than later systems since it was influenced by the flash-to-subject distance only, and was not fooled by subjects of unusual reflectance characteristics. The CAT System was followed by the simple automatic flash systems introduced for the A-series cameras and early T-series cameras. It was not until the T90 that Canon finally introduced the long-awaited TTL OTF flash metering which we take for granted today.

Almost anyone who owns a high-quality camera like any of the Canon cameras discussed in this book will want a flash unit of equal quality to go with it. Not only is flash useful for taking photos indoors or outdoors in dim light or at night, it is also even more useful on the brightest, sunniest days. It can be used for fill-flash to reduce the contrast of a scene and render direct sun much less harsh in the finished photo. Amateur photographers will look at you like you are insane when they see you shooting with flash in bright sunlight. One of the authors has even had a helpful amateur advise him that his photos would not turn out since he was "accidentally" firing his flash in broad daylight.

The light from small, camera-mounted flash units is very directional and harsh. The reason for this is the cardinal rule of lighting, that the hardness or softness of the light is determined by the apparent size of the light source from the subject. The harshest possible type of lighting is a point light source such as the sun on a clear, cloudless day. The sun is gigantic, but appears as a tiny

◁ **This casual snapshot was lit with automatic exposure flash. Detail was retained in the dark background and dark sweatshirt without overexposing the boy's face.**

point source of light because of its distance. Similarly the tiny flash tube used in electronic flash units acts as a point light source.

The softest type of light is found on a bright but uniformly cloudy or overcast day, when the apparent light source is the entire sky. Studio photographers soften the light from their flash units by using big "soft boxes" on the flash units or by shooting the flash through a fabric screen, both of which increase the apparent size of the light source. For on-camera flash, large soft boxes are not practical, but the light can be softened somewhat by the use of miniature softboxes such as those made by Lumiquest®, Photoflex® and others. These are highly recommended for more natural appearing photographs. One important caveat: when using any such device on a standard automatic flash unit, make sure that the light sensor on the front of the flash is not blocked by the accessory. This will result in incorrect flash exposure.

Guide Numbers

Although you will not need to use them with automatic flash units, it is still a good idea to be familiar with the concept of guide numbers, if for no other reason than they are frequently quoted in flash advertisements. The guide number of a flash is a measurement of its relative light output, and is derived by a simple formula. However, it is important when comparing guide numbers to make certain that they are measured at the same ISO number, since some manufacturers cheat in their advertising and literature by using a non-standard guide number. By convention, all stated guide numbers are to be measured at ISO 100. It is also important to know whether the stated guide number is in feet or meters.

The simple formula for guide number is:
Guide Number = Lens Aperture Number x Distance to Subject

By using this formula, you can compute any of the three variables if you know the other two. If you want to know the guide number of a flash, then you would shoot a series of photos of a subject at a known distance (say ten feet for simplicity) at each aperture on the lens and determine which one was correctly exposed. As an example, say the one shot at f/5.6 is the best expo-

If a slow shutter sync speed is used with fill flash, the subject and the camera must remain still or blurred images will result.

sure. Multiplying 5.6 x 10 feet gives us a guide number of 56 in feet. Once you know this, you can then calculate the correct lens aperture for any distance by simply dividing the distance into 56. Or if you want to know the best distance for a particular aperture, then divide that aperture into 56. Most flash units have a stated guide number in their instruction booklets, but do not rely on this without tests of your own, since many manufacturers tend to over-state guide numbers.

If your flash states its guide number as a metric guide number, you can convert to an approximate one in feet by multiplying by 3.3, and conversely, to convert a guide number in feet to meters you can divide by 3.3. As stated earlier, this is all you will need to know about guide numbers since they are very rarely used today in this time of automatic flash equipment.

This snapshot of a bunny was taken using an AE-1 camera with a Speed-lite 155A flash set in automatic mode. The sensor on the front of the unit determined the correct exposure.

Automatic "Sensor" Flash

Automatic "computer" flash equipment uses a light sensor mounted on the front of the flash that is pointed toward your subject. This sensor measures the flash light reflected back from the subject and, through the circuitry of the flash, shuts down the flash tube when sufficient light has reached the subject. Early automatic flash units dumped the excess energy stored in the flash capacitor through a second flash tube, effectively wasting it. Later computer flash units use a special transistor called a "thyristor" to retain the unused energy in the system and use it in subsequent flashes. The difference is that the recycle time, the time between flashes, is much longer at normal distances with the non-thyristor units.

In operation, computer flash units are very easy to use. You simply set the ISO speed of the film you are using on a dial or sliding scale on the flash. This scale shows you a lens aperture to use,

or in the better units several options of apertures to pick from. Just set the same lens aperture on the lens you are using and you will get correctly exposed flash photos.

If you wish to use automatic flash for fill-flash operation, you will probably find that following the above procedure produces artificial looking images because the flash-fill light will be as bright as the ambient light. To solve this problem, close down the camera lens one stop more than indicated on the flash. For example, if the flash indicates f/5.6, then set the lens for f/8 and choose a corresponding shutter speed for the ambient light exposure. (Just make certain it's not faster than the sync speed.) The photograph is properly exposed by the ambient light with a one-stop underexposure from the flash so the fill light is subtle and not overpowering.

Using Flash with Canon Cameras

Synchronization
All Canon SLR cameras use focal plane shutters made either of cloth or the more recently introduced EMAS (Electro Magnetic Attraction Shutter) composed of metal and/or plastic blades. The fabric shutters move horizontally on rollers, while the bladed shutters move vertically and thus, travel a shorter distance. On all such shutters, the first curtain or set of blades flips open to allow light to reach the film and then the second curtain or set of blades flips closed to end the exposure. However, it is not possible to drive the curtains or blades fast enough to fully open and close for very fast exposures, so at faster shutter speeds, the second set is released before the first has fully opened. This creates a slit between the first and second curtain or first and second blade sets which travels rapidly across the film. If an electronic flash is fired during such an exposure, it will only illuminate the part of the film which is uncovered by the slit and not the rest of the film. Therefore, flash can only be used at shutter speeds at which the first curtain or blade set is fully open before the second curtain or blade set begins to close. The fastest speed at which this takes place is referred to as the flash sync speed of the camera. Of course, slower speeds may be used with flash as well.

On the Canon cameras from the F-series through the A-series and including the T50, the flash sync speed is 1/60 second, which

is the highest sync speed possible with Canon's cloth shutters. With the introduction of the EMAS-type shutter on the T70, this speed was increased to 1/90 second, and it was increased again on the T90 to a very fast 1/250 second.

Dedicated Automatic Flash
A "dedicated" flash unit is designed to work with a particular brand, series or model of camera. In the Canon cameras first became significant with the A- and T-series cameras. With these cameras, properly dedicated flash units will automatically set the camera to the correct flash sync speed when mounted on the camera and switched on. Canon Speedlites of the A-series will also automatically set the correct lens aperture if the aperture ring on

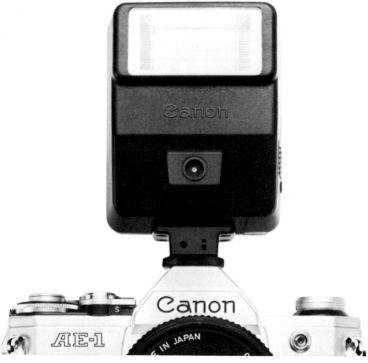

The Speedlite 155A was introduced with the AE-1 camera. It attaches to the camera's hot shoe and offers automatic operation with a choice of two aperture settings.

the FD lens is set to the automatic position. This is truly fully-automated flash operation.

Automatic Preflash

Canon Speedlites in the T-series have a unique system of measurement that occurs prior to the actual exposure by sending out an infrared preflash, measuring the reflectance, and using this information to determine the correct flash exposure. This is a very accurate system, which has worked extremely well. These flash units will work with Canon A- and T-series cameras. Naturally, you must use FD lenses and they must be set to the automatic position on the aperture ring.

A- and G-Series Speedlites

Speedlite 133A: This flash was introduced with the Canon AV-1, but works with all of the other A-series cameras. It provides automatic setting of the flash synchronization speed and full sensor flash automation with these cameras. It has a guide number of 53 in feet or 16 in meters, and provides automatic exposure at a single aperture of f/4. The distance range is from approximately 1.7 to 13 feet (0.5 to 4 meters).

Specdlite 155A: This was the first Speedlite in the A-series and was introduced with the original AE-1 camera. It has two possible aperture settings for automatic operation, f/2.8 and f/5.6. With a guide number of 56 in feet or 17 in meters, the maximum distance at which it can be used is about 20 feet (6 meters).

Speedlite 166A: This flash was introduced with the Canon AL-1, Canon's first autofocus SLR camera. It offers a guide number of 66 in feet, 20 in meters and it offers a selection of either f/2.8 or f/5.6 for automatic "sensor" flash exposures. The maximum distance at which it can be used is about 23 feet (7 meters).

Speedlite 177A: This flash has a guide number of 83 in feet or 25 in meters, making it a very powerful flash. It is nearly as powerful as the large, professional Speedlite 199A. However, unlike the 199A, it does not have a tilting head and it offers only two apertures for autoexposure, f/2.8 and f/5.6. The maximum range of this flash is about 30 feet (9 meters).

Speedlite 188A

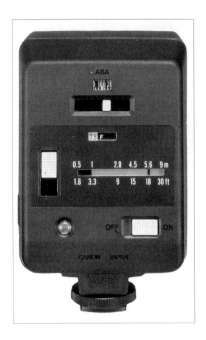

Speedlite 188A: The Speedlite 188A was introduced with the Canon AE-1 Program camera. It has the same guide number as the 177A, and also has the same two aperture choices for automatic exposures. In addition to all of the features of the 177A, the 188A also provides a "Flash Ready" signal in the viewfinder when used with the AE-1 Program camera.

Speedlite 199A: When the A-1 was introduced, so was the Speedlite 199A, the flagship of the Speedlite line. The 199A is a large flash which mounts on the camera's flash shoe. The flash offers three aperture selections for automatic exposure, f/2.8, f/5.6 and f/11. The maximum distance with automatic flash is about 33 feet (10 meters). A test flash button can be used for verification of sufficient light in autoexposure. It produces a green "OK" signal after a test flash. Also the reflector head on the 199A can be tilted up for bounce flash without losing the automatic exposure function.

For close-up photography, diffuse the light from a flash unit with a soft box or diffusion panel.

Speedlites 533G and 577G: These two flash units were introduced with the Canon New F-1 camera, but can also be used with any of the A-series or T series cameras. These flash units feature flash heads which both tilt and swivel, for extra versatility in using bounce flash regardless of whether the camera is positioned for horizontal or vertical photos. They offer automatic exposure with a choice of f/2.8, f/5.6 or f/11, and also offer an external sensor which mounts in the flash shoe of the camera for correct automatic exposure regardless of where the flash is pointed. The flash angle can be adjusted to match a lens as wide as 20mm in focal length.

The Speedlite 533G has a guide number of 119 in feet or 36 in meters when the reflector is set for a 35mm lens, and a maximum range in this position of 43 feet (13 meters).

The Speedlite 577G is even more powerful, with a guide number of 158 in feet or 48 in meters, and a distance range up to 56 feet or 17 meters. It can also be set for manual operation.

Power for the 533G is provided by 6 AA alkaline or NiCd cells housed in the handle of the flash. The 577G has a larger capacitor which does not leave room inside the flash for a power source, so it must be powered by the external Transistor Pack which operates from 6 AA or rechargeable C cells.

T-Series Speedlites

Speedlite 244T: The first flash of a new generation, the 244T was introduced with the Canon T50 camera. It has a guide number of 53 in feet or 16 in meters. It offers three aperture choices for automatic flash, f/2.8, f/4, and f/5.6. The maximum flash distance in automatic is up to about 19 feet (5.7 meters).

Speedlite 277T: With a guide number of 83 in feet (25 in meters) and a distance range in automatic of up to about 41 feet (12.5 meters), this is a very versatile flash. It operates in automatic at any aperture from f/2 to f/22, and features an infrared pre-flash for very accurate exposure determination. In fact, the only feature lacking on the 277T is full TTL flash capability.

Speedlite 299T: The Speedlite 299T is the last of the T-series flash units. In addition to the features of the 277T, the 299T adds a tilting and rotating flash head, and an adjustable reflector. This can be set to match the flash coverage to the angle of view of 28mm, 35mm, and 85mm lenses. The guide number varies with the flash angle, of course, and ranges from 83 feet (25 meter) to 132 feet (40 meter). Maximum distance also varies, and ranges from about 41 feet (12.5 meters) to 66 feet (20 meters).

Canon TTL Flash

TTL (Through The Lens) flash is a refinement of automatic flash, and works in a very similar manner. However, instead of using a sensor mounted on the front of the flash, pointed toward the subject, TTL systems have a sensor inside the camera pointed back at the film. This sensor actually measures the light from the flash as it is reflected off the film's surface.

In theory this is much more accurate since it takes into account

anything introduced into the imaging path, such as filters, bellows extension tubes, teleconverters, etc. It adjusts for these automatically in the process of calculating exposure because the light it measures has already passed through these attachments. In actual practice, TTL flash is not necessarily more accurate than simple automatic flash for most applications.

Of the classic cameras in this book, only the T70 and T90 will operate with TTL flash with the correct flash unit. When deciding which sort of flash unit to purchase for use with your Canon classic camera, the best advice is to buy a good flash unit made by Canon or a major flash manufacturer. If you have questions, see a knowledgeable Canon camera dealer.

Speedlites for TTL Flash
Speedlite 300TL: Canon's first flash with TTL metering, the 300TL was introduced for the Canon T90 camera. It can also be used as a standard automatic flash, plus it has manual flash with power adjustment from full power to 1/16 power. Recycling time is very

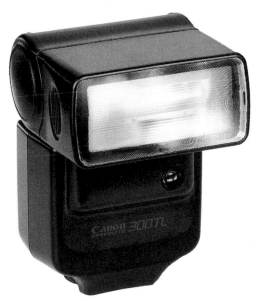

The 300TL sends out an infrared preflash to measure the amount of light required to properly expose the subject.

quick at these lower powers, making the flash usable with the T90's fast, motorized operation.

The flash head of the 300 TL tilts and rotates, allowing maximum versatility for bounce flash use. The reflector is also a zoom reflector, with settings for 24mm, 35mm, 50mm and 85mm lenses. The guide numbers at these settings are 83, 99, 116, and 132 in feet (25, 30, 35, and 40 in meters). The distance range varies from 41 to 66 feet (12.5 to 20 meters). The 300 TL also has Canon's SE (save energy) circuit, which will shut the flash down if it is not used for five minutes or longer to conserve battery power.

This was also the first flash from Canon that offered second curtain flash sync. When used with a slow shutter speed, the flash can be set to fire at the end of the exposure just before the shutter closes instead of at the beginning of the exposure when the shutter has first opened. For photos of moving subjects in mixed lighting, this creates more realistic looking photos because the ambient light image appears to trail behind the flash exposure.

The 300 TL flash can also be taken off the camera and set up some distance away while maintaining full TTL automatic flash operation by means of the External TTL Adapter and the Connecting Cord 60 (about 2 feet or 60 cm in length) or the Connecting Cord 300 (about 10 feet or 3 meters in length). A maximum of four flash units can be used by hooking them up to the TTL Connector Plate.

Macro Flash Units

Canon offered two specialized flash units for close-up and macro photography, the Macrolite ML-1 and the Macro Ring Lite ML-2. The ML-1 is an automatic flash designed for simple operation with the A- and T-series cameras. The ML-2 is a much more sophisticated unit designed for full TTL autoexposure with the T90 camera.

These special flash units are made in two pieces. The main body of the flash, housing the power supply and capacitors, fits on the camera's accessory shoe and makes direct connection with the camera, while the flash head attaches to the filter ring on the front of the lens. The two parts are connected by a cable which carries energy from the power supply to the flash tubes. The flash head of the ML-1 has two small rectangular flash reflectors mounted on it. The ML-1 has a control box that mounts on the camera's flash shoe, and is powered by a separate battery holder which houses

To illuminate only the flowers and leave the brick wall in shadow, the flash unit was positioned off to the side. The flash was connected to the camera with a cord but it could also have been triggered using a Wein® infrared remote control unit.

eight AA batteries or AA NiCd rechargeable batteries. While it performed adequately, the ML-1 could not provide automatic correction for lens extension or bellows extension, which still had to be computed manually by the photographer. While the Macro Lite ML-1 can produce interesting flash effects at moderate distances up to about ten feet, it is not recommended for use in true macro photography because, at close distances, the flash will not give accurate exposure. The guide number is 53 in feet or 16 in meters.

Macro Ring Lite ML-2: The Macro Ring Lite ML-2 is a fully automatic TTL flash with a guide number of 36 feet (11 meters). It is a two-piece unit, with the generator and power supply mounted on the camera. It is powered by four AA alkaline or rechargeable NiCd batteries. In contrast to the ML-1, the ML-2 has the appearance of a ring light with a single circular reflector and diffuser.

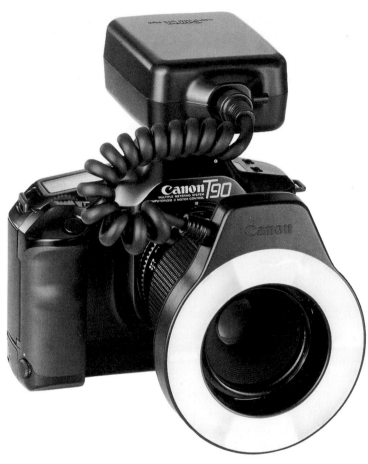

The ML-2 Macro Ring Lite, introduced with the T90, provides soft, diffused lighting for small, close subjects.

The ML-2 looks like a traditional, round ring light, but actually has two arc-shaped flash tubes mounted behind the round diffuser. This flash unit, introduced for use with the T90, provides fully-automatic TTL flash operation. It eliminates having to compute exposure factors for lens or bellows extension, fully automating macro flash exposure.

When the ML-2 is used in TTL automatic mode, it can be used at any lens aperture. It also has two manual settings, with guide numbers of 36 feet (11 meters) in the HI setting and 18 feet (5.6 meters) in the LO setting. This enables the photographer to control of depth of field or use of a faster shutter speed when desired.

The flash sync speed is automatically set on the camera when the flash is set for TTL automatic and is fully charged. The ML-2 also has an energy conservation feature and shuts off if unused for five minutes.

Accessories for A- and T- Series Cameras

With a well-engineered Canon A- or T-series camera body, a quality Canon FD lens, and today's excellent film technology, it is difficult not to take good photographs. However, accessories manufactured by Canon and others can help make picture-taking easier and more rewarding.

Winders and Motor Drives

Canon made the winder and motor drive "household words" by offering them as accessories for its popular A-series cameras. Due to this success, Canon incorporated built-in drives into most T-series bodies and continues to offer integral drives in all current models.

Cameras from Canon's A-series can have an accessory motor drive attached to the bottom for fast, automated film advance. Some photographers feel that this is an advantage because the motor can be attached and used when the photographic situation calls for fast photography, but it can be removed and put it away when not needed. This makes it easy to shed extra weight when a motor drive is not really called for.

There are two types of motors available, one type is generally referred to as "winders" and the other, "motor drives." Generally speaking, this is an artificial distinction, since the difference between the two is that a motor drive advances the film faster than a less-powerful winder. Which type you should use depends on how quickly you need to advance to the next photo, and whether you need continuous advance.

Canon Winders A and A2
The Winder A was originally introduced with the AE-1 camera. The Winder A2 came out later with the AE-1 Program camera. Both winders can be used with any of the A-series cameras, and can also be used on the New F-1 but they do not offer automated film rewind on that camera. The Winder A2 is a little bit thicker

The Winder A was originally introduced with the AE-1 camera, but can be used with any of the A-series cameras. On the top of the winder from left to right is the motor drive coupling, the mounting screw, which threads into the cameras tripod socket, and the clip for storing the cap that covers the camera's motor drive coupling.

than the original A model, and this prevents a camera with a short lens mounted from tipping over on its face when set down.

Both winders attach to the camera body in the same way. On the bottom of the camera at the right-hand end is a small round metal cap which must be unscrewed with a coin. This cap can be stored under the spring clip on top of the winder to prevent its loss. Once the cap has been removed you will see the motor drive coupling inside the camera. The motor is then mounted onto the camera by holding it in place while tightening the screw which goes into the tripod socket on the camera body. Tighten it firmly so it won't come loose, but do not overtighten. The winder covers up the film rewind release button on the bottom of the camera, so a supplementary rewind release button is provided on the bottom of the winder.

Both winders are powered by four AA-size alkaline batteries. Carbon-Zinc cells are not recommended except in an emergency when they are the only batteries available. The original Winder A can only be used with these two battery types. The Winder A2 has a modified circuit and can also be used with AA-size NiCd rechargeable batteries. Be careful when loading the batteries into the winder to observe the indicated polarity, since installing the

batteries incorrectly will make the winder work improperly or can damage it. With fresh batteries and the camera set for 1/60 second exposure, the Winder A can shoot as fast as two frames per sec-

Use a winder or motor drive to make a series of pictures of a moving subject. Lighting on the subject must remain consistent throughout the series, otherwise, not all of the pictures will be correctly exposed.

ond. However a continuous series is not possible because you must remove your finger from the shutter speed button and press it again for each succeeding frame.

The Winder A2 is more advanced and offers the choice of single frame advance as well as continuous operation. However, the continuous advance is only two frames per second, which may not be fast enough for really rapid action. Also, the Winder A2 can be used with a remote release cord for automated operation from a distance. Theoretically, you can also use the Winder A in such a way by connecting a long cable release or air bulb release to the shutter release button of the camera, but we do not recommend this for extended operation due to the possibility of damaging the camera. If you plan to do a lot of work with a remote release, then the Winder A2 should be your choice.

Motor Drive MA
The Motor Drive MA was introduced to work with the A-1 camera. The Winder A and A2 will also work with this camera, but the speed is limited to single frame advance with the Winder A or two frames per second with the Winder A2. The Motor Drive MA is much faster and capable of exposing a full five frames per second with the A-1 camera. The Motor Drive MA will also work on the AE-1 Program, but slows to four frames per second on this camera. The Motor Drive MA is not recommended for use on other camera models in the A-series.

The Motor Drive MA is L-shaped in layout with a handgrip which comes up in front on the right hand side of the camera. The bottom attaches to the camera's tripod socket just like the winders. The Motor Drive MA is considerably heavier than the winders. One reason for this is that it requires twelve AA-batteries (Alkaline recommended) to operate. It is also possible to power it with the NC-Pack MA, which houses twelve NiCd rechargeable cells.

With the main switch on the Motor Drive MA you can set three advance modes: "S," for single frame advance in which it operates like the Motor Winder A and advances one frame each time the shutter release button is pressed; "L," for low-speed, continuous advance; and "H," for high-speed continuous advance. On the "L" setting the camera will advance at a maximum rate of 3.5 frames per second with alkaline batteries or three frames per second with NiCd power, while on the "H" setting it will advance at

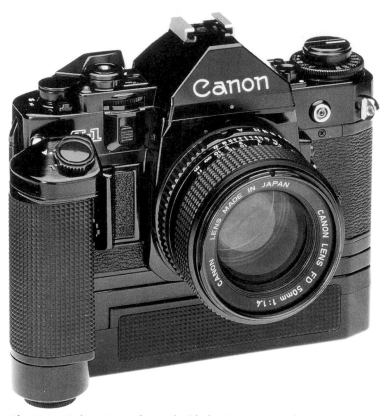

The Motor Drive MA can be used with the Canon A-1 and AE-1 Program cameras for continuous film advance of up to 5 frames per second and 4 frames per second, respectively. Single frame advance and low-speed continuous advance can also be set. The Motor Drive MA can be powered with either alkaline or NiCd batteries.

a maximum rate of five frames per second on the A-1 and four frames per second on the AE-1 Program (with alkaline cells).

This motor advances the film only, the photographer must still manually rewind the film when the roll is finished. The rewind release button on the bottom of the motor couples to the one on the camera body. It must be pressed before using the crank to rewind the film into the cassette.

The Motor Drive MA is fitted with a socket for a remote release cable for automated operation at a distance, and there was also an accessory intervalometer available for fully automatic operation.

Data Backs

It is standard for the camera back on all A-series cameras and all T70, T80 and T90 cameras to be removable so that accessory backs can be added.

On the AE-1, AT-1, AE-1 Program and A-1, the back is removed by opening it and swinging it all the way open. On the hinge side you will see a small chrome pin protruding from the hinge. This pin is moved sideways in its slot and this retracts one of the hinge pins allowing the back to be swung away and removed from the camera. Fitting an accessory back is a simple matter of reversing this procedure. The data backs for these cameras can be used to record the data desired directly onto the film at the time of exposure.

This is often useful for archiving purposes, or when the photographer would like to remember the date on which a photo was taken. Naturally, the data back can also be set to not imprint information onto film frames.

Data Back A
The Data Back A for the A-series cameras is designed to print dates or number sequences onto the film during exposure. It replaces

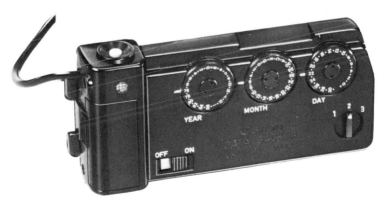

The Data Back A, designed for A-series cameras, imprints information directly onto the film. By using a switch on the lower right, the brightness of the internal light can be adjusted to ensure the best possible data imprint for the film in use.

the standard camera back as described above. Data is set on this back using three input wheels on the rear face of the Data Back A.

Unfortunately, when this product was introduced no one realized that we would still be using A-series cameras today, so the range of years on the first control wheel only goes up to 1987. Roman numerals from I to X are also included, so current years could be indicated by the Roman numeral for the second digit, or you can work out your own personal code for current years. The second wheel can be used for months, but also has numbers from 1 up to 31 as well as letters from A to G. The third wheel has numbers from 0 to 31. Obviously you can use the three wheels to encode other data as long as it can be encompassed by the available choices. There is also a three-position switch on the back which controls the brightness of the internal light to match the film speed. A short cable coming from the left-hand side of the Data Back A must be plugged into the PC socket on the camera for proper operation. If you wish to use the Data Back A and a non-hot shoe flash at the same time, you must plug the PC cord from the flash into the PC socket on the Data Back A.

Data Backs 70 and 90
The Data Back 70 made especially for the T70 camera does everything that the Data Back A does, and in addition, offers the functions of an automatic timer and intervalometer for fully automatic camera operation. Because of the use of modern electronics, the Data Back 70 is hardly thicker than the standard camera back and does not add bulk as the Data Back A does. The Data Back 90 for the T90 also has the same functions and barely adds to the size and weight of the camera. On these data backs, information is displayed on the built-in LCD panel, and is input through a series of buttons.

Built into these backs is a quartz-timed clock and calendar, which will run through the year 2029 on the 70 and through the year 2099 on the 90. The correct date is automatically set, and the photographer has merely to decide whether to imprint it and in which order: Month/Day/Year, Day/Month/Year, or Year/Month/Day. The photographer may also choose the Day/Hour/Minute setting as well. It is also possible to encode alphanumeric sequences.

Another function built into these data backs is the timer. This can be set from 1 second up to 23 hours 59 minutes and 59 sec-

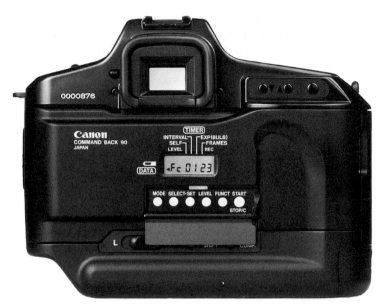

Slimmer and more sophisticated than the Data Back 90, the Data Command Back 90 can store and recall information on exposure settings, flash, time, date, and film speed for every exposure on as many as nine rolls of film.

onds. It will keep the shutter open for the set length when used as a shutter timer, or can set the interval between photos when used as an intervalometer. The intervalometer can be invaluable for research since it can shoot a 36 exposure roll with one frame every second, using up the roll in 36 seconds, or it can be set for a longer delay all the way to 24 hours (less one second), making it shoot one photo every day, using up the roll in 36 days. The actual number of photos in a series can be preset from two all the way up to 99 photos. Too bad there are no 99-exposure rolls!

The data backs are powered by their own batteries, in this case a special Lithium cell of the type CR2015 (for T70) or type 2025 (for T90).

Data Command Back 90
In addition to all of the functions of the above data backs, this special back for the T90 also stores information for later recall. It can store up to sixteen different pieces of data for every exposure on four 36-exposure rolls of film. Or if you prefer, it can store six bits of data for nine 36-exposure rolls. Information that can be stored and recalled is shutter speed, aperture value, metering mode, exposure mode, flash or no flash, open or stopped-down aperture, exposure compensation, number of exposures made, film speed, 4-digit frame number, time and date, and lens data for lens in use.

Remote Releases

Cable Releases
The shutter release buttons of the A-series cameras are fitted with a threaded socket that accepts a standard cable release. This allows for remote firing of the cameras or for reducing vibration when the camera is mounted on a tripod or other support.

From the T70 onward, Canon cameras no longer had this threaded socket for a mechanical release, having instead a proprietary electronic socket that accepts Canon electronic remote release cables. These come in several lengths with the shortest, the 60T3, being 60 cm in length (about two feet), and the longest,

T-series cameras accept an electronic rather than a mechanical cable release. The shorter 60T3 cable release (shown here) is excellent for preventing camera shake with macrophotography and long exposures.

The Infrared Remote Release LC-1 is used to remotely fire a Canon A-series camera. The transmitter (left) sends out a coded infrared pulse when triggered. The receiver (right), which must be connected to the camera through a Canon Winder A2 or Motor Drive MA, fires the camera when it senses the infrared signal.

the 1000T3, being 10 meters in length (about 33 feet). The maximum length of cable which can be used without electrical loss and failure of function is 100 meters or 330 feet.

Infrared Remote Release LC-1
This Infrared Remote Release is made for use with the A-series cameras and consists of a hand-held transmitter and a camera-mounted receiver. The transmitter and receiver can be set for three different channels, which means that one transmitter can be used to operate up to three remote camera outfits. Because the receiver connects electrically rather than mechanically, it can not be connected to a camera that does not have a Winder A2 or Motor Drive MA attached. The mini-plug on the receiver cord plugs into the socket on the winder or motor drive, and not into the camera. Under optimal conditions the range of the LC-1 is around 60 meters, or about 200 feet. The transmitter and receiver operate on line of sight, so it is important to aim the transmitter directly at the receiver, particularly when used outdoors. Inside the infrared beam can bounce from walls and ceilings to reach the receiver.

The Infrared Remote Release LC-2 connects to Canon T-series cameras and can fire the camera remotely from a distance of up to 16.5 feet (5 m). It has two channels that each generate a different coded pulse, allowing two cameras with receivers to be triggered separately.

Infrared Remote Release LC-2

The LC-2 is designed for use with the T-series cameras. Operationally, the LC-2 is similar to the LC-1, but the two parts are housed in much slimmer and more stylized housings. The transmitter of the LC-2 has only two channels, so only two remote cameras may be controlled with it. If more cameras must be operated, they can be wired together in parallel and triggered together.

It is possible with the LC-2 to take continuous series photos with the T50, T70 and T80 cameras, at a speed of about one frame per second, by holding down the button on the transmitter. This also works with the T90, and at a speed of 2.5 frames per second.

The LC-2 can also operate with a two second delay between the signaling of the transmitter and the photo being taken. The maximum distance at which the LC-2 can operate is only 5 meters, 16-1/2 feet.

Filters

Protective Filters and Lens Care

Many photographers always keep a skylight or UV filter on the front of each of their lenses for protection. While this is good insurance for many, the authors do not follow this practice except in unusually dusty or dirty environments or, perhaps, at the beach to keep salt spray off the front of the lens. Adding any filter to a lens increases the air/glass interfaces. This increases the likelihood of lens flare and ghost images, and a low-quality filter could degrade the fine image quality of Canon lenses. If you decide not to use a "protective" filter all the time in normal circumstances, it makes more sense to periodically clean the front of the lens properly.

Proper lens cleaning is not difficult. The first step is to blow away loose dust and grit with an air bulb blower. One of the best, is an ear syringe available from pharmacies. Hold the lens with the front pointing down so that gravity will carry away the dirt as it is loosened and blow the entire glass surface as well as the name ring and filter threads where dust can hide. If a careful inspection with a bright light reveals more material clinging to the lens surface, then you need to be more aggressive in your cleaning. When one of the authors toured some of the Canon factories, he was surprised to see that ordinary slide projectors were used as the light source by the inspectors who checked lenses and prisms for dust. This makes a lot of sense, since the beam of light from a slide projector is focused, and will make even the smallest dust speck stand out. If you do not have a slide projector, try a high-intensity halogen desk lamp or similar bright light.

Stubborn dust is best removed with a soft "camel hair" brush (actually made from squirrel tail hair). If careful brushing and blowing, always with the lens pointed down, do not remove the offending matter, then, and only then, should you resort to lens cleaning liquid. Always put the lens cleaning liquid onto a lens tissue or lens cleaning cloth, never directly onto the lens. Use a gentle

circular wiping motion starting in the center of the lens and working out to the edges. Then use a dry part of the tissue or cloth to gently buff the lens dry. The microfiber lens cloths now available from a number of suppliers do a particularly good job of cleaning. Do not overdo the cleaning regimen, once every month or two is plenty, and a few specks of dust will not harm your photos. Lenses need to be clean, not virginally pristine.

UV and Skylight Filters

UV filters are properly used not for lens protection but for reducing the effects of atmospheric haze produced by excess UV light. This is rarely a problem in normal situations, but can be at high altitudes. UV filters can also be useful in some high glare situations, such as deserts.

A Skylight filter is nothing but a UV filter with some slight warming added to it. This can be useful in some situations, but modern color slide films tend to have a warm balance anyway making the use of this filter unnecessary.

Polarizing Filters

The Polarizing filter makes use of one of the properties of light to allow the photographer to "tune out" reflections by rotating the filter. While light has both particle and wave properties, it is the wave properties we are dealing with when discussing polarization. While ordinary light oscillates with all planes intermixed, polarized lightwaves all oscillate in one plane. When light is reflected from most surfaces, it is reflected as polarized light. By using a polarizing filter, which passes light oscillating only in one plane, the filter may be rotated to either allow the reflected light to pass, to block it, or to only let part of it pass. In practice, this allows the photographer to completely eliminate most reflections or to fine tune the filter to pass just the desired amount of reflection. This works for reflections on water, glass, and most polished surfaces, but does not work on reflections from polished metal surfaces because, unique among reflections, these are not polarized.

A Polarizing filter can also be used to produce saturated colors and to darken skies in photographs. Surfaces which are not necessarily thought of as reflective appear to be more richly colored when a Polarizing filter is used to eliminate subtle glare. Because

skylight contains a considerable amount of polarized light, use of a Polarizing filter produces darker blue skies in photographs.

Colored Filters

While filters come in a wide variety of colors, these are generally used in black-and-white photography. When used in this way, filters will lighten colors similar to the filter color and darken complimentary colors. For example, a yellow, orange or red filter can be used to darken blue skies and make clouds stand out dramatically. Yellow produces a mild effect, orange a bit more and red an extreme effect. Another good example is in taking a black-and-white photo of an apple tree full of ripe red apples. If you take the photo with no filter, you will find that the leaves and apples are rendered in similar shades of gray, and there is no distinction. If, however, you take the photo through a red filter, the apples will be rendered in a light shade of gray while the leaves are rendered quite dark. Conversely, if you use a green filter you will end up with light tone on the leaves and dark apples. Choosing which filter to use depends on the effect you want in the final photo.

Neutral Density Filters

Also called ND filters, these are optical glass which is neutral gray in color and has no effect on color rendition in black-and-white or color photography. The purpose of a ND filter is simply to block out light without having to change the lens aperture, shutter speed or the film. For example if you want to take a photo on a bright day but want to use the lens wide open to blur a background, then the ND filter will let you do this. Conversely, if you want to use a very slow shutter speed for motion blur but do not want to close the lens down all the way, you can accomplish this with an ND filter. ND filters come in different grades of darkness for a variety of applications.

Graduated neutral density filters: In addition to the traditional round filters which screw on to the front of the camera lens, there are also square and rectangular filters, such as the filter systems offered by Cokin®. With this system, an adapter screws on to the lens and the filter is slipped into a slot in the holder. Many interesting filters are available for these systems which are not available as round screw-on filters. One particularly useful Cokin filter

Using a magenta filter for this black-and-white photograph lightened the pink roses and darkened the green foliage. Adding contrast this way makes the roses really stand out.

is a graduated neutral density, or gray filter. This filter is clear on one side and gradually darkens toward the other side. When mounted on the camera, you can turn it so that the dark part of the filter is toward the sky and the light part is on the foreground. This allows you to darken a very bright sky without having any effect on the rest of the picture. In the square and rectangular versions, you can slide the filter up and down to adjust the dark part to be just where you want it. These come in different degrees of density, as well as with or without color tint, which allows a lot of creativity in picture taking. For more information on filters, see your specialty photo dealer.

Soft Focus or Diffusion Filters

Among my favorite filters, these are used to introduce a soft, dreamy quality to photos. They are particularly effective for

glamour and still-life subjects. Every major filter maker offers one or more of these, and they are all different. You will have to experiment to find the one which is right for you.

Camera Support

Generally speaking you can hold a camera and lens steady if the focal length of the lens is approximately matched by the shutter speed. For example, a 135mm lens generally requires a shutter speed of 1/125 second or faster for hand holding. Similarly, a 200mm lens would be used at 1/250 second or faster and a 500mm lens at 1/500 second or faster. This is only a general rule since some people are steadier than others, and if you want to do a lot of hand-held photography with telephoto lenses I advise you to make a series of tests to find out what your own personal limits are.

Once you know those limits, you will know when a supplementary support system will be needed. Supplementary supports include tripods, as well as the monopods and a variety of pistol grips, rifle stocks and other gadgets. You can only determine which are right for you by personal trial and testing. In the experience of one of the authors, the monopod is the preferred system, being light and small enough for travel anywhere in the world, and allowing reasonably slow shutter speeds to be used with long telephoto lenses.

Notes